# ink

T0386143

GSAPP Books—New York

GSAPP BOOKS
An imprint of The Graduate School of Architecture, Planning, and Preservation
Columbia University
1172 Amsterdam Ave.
409 Avery Hall
New York, NY 10027

Visit our website at www.arch.columbia.edu/publications

This book has been produced through the Office of the Dean, Mark Wigley, with
production coordination by Jordan Carver, Office of Print Publications.

Graphic Design—Kate Dewitt
Copy Editor—Ellen Tarlin
Production—Printed in China by Shenzhen Caimei Printing Co., Ltd

SPECIAL THANKS
Thanks to the Office of the Dean, in particular, to Mark Wigley for his
incomparable support; to the Office of Print Publications, Craig Buckley, and
especially Jordan Carver for his inspired and unfailing guidance; to Kate
Dewitt for her elegant design; to Jesse Robert Coffino, Nanette Fornabai and
Sarah McNaughton for their subtle translations; to Ellen Tarlin for her close
readings; and to the contributors to this book for their generosity and brilliance.
Thanks also to Gavin Browning, Martin Bridgeman, Peter Fornabai, and Judith
Fornabai for their tremendous support; and to the GSAPP, Studio-X New York,
Studio-X Beijing, and the Weatherhead East Asian Institute for their support of
the project in its nascent phase.

ISBN 978-1-883584-90-6

## Ink Contributors

Martin Ariza Medrano, Sunil Bald, Gilles Balmet, David Benjamin, Ila Berman, Martin Bridgeman, Gavin Browning, Babak Bryan, Amy Carpenter, Alexis H. Cohen, Craig "KR" Costello, J. Yolande Daniels, Sean A. Day, Qin Feng, Karen Finley, Michelle Fornabai, Peter Galison, Martin Gayford, Takeshi Iizuka, Wendy Jacob, Pavitra Jayaraman, Caroline A. Jones, Roland Juchmes, Karel Klein, Pierre Leclercq, Peter Logan, Diana Martinez, Thom Mayne, Kate MccGwire, Dean Motter, Nashid Nabian, Daisy Nam, Javier Navarro Alemany, Taeg Nishimoto, Tom Norton, Eiji Osawa, Spyros Papapetros, Jason Payne, Karla Rothstein, Heather Rowe, Teri Rueb, Yehuda E. Safran, Pamela Sams, Ashley Schafer, Richard Evan Schwartz, Sha Xin Wei, Galia Solomonoff, Nader Tehrani, Marc Tsurumaki, Kazys Varnelis, Catherine Veikos, Anthony Vidler, Enrique Walker, Wei Jia, Mark Wigley, Mabel O. Wilson, Xu Bing, Xu Li, Akira Yamasaki, Soo-in Yang, Michael Young

## Historical Ink

Carl Andre, Neil Armstrong, Jane Austen, Denis Diderot, Le Corbusier, Adolf Loos, Henri Michaux, Marcus Vitruvius Pollio, Chiang Yee, Zhang Xu

## Ink Translators

Jesse Robert Coffino, Nanette Fornabai, Sarah McNaughton

# Introduction

# An A to Z of Ink in Architecture

Beginning within my studio, I constructed a hidden alphabet game of 104 ink objects as a means to reflect, quite simply, on ink.

Composed from various material forms of ink found in an architectural studio, an alphabet in 26 images was created and sent as an invitation to architects, artists, historians, theorists, scholars, inventors, and poets to write a brief entry on a discrete ink object. Within each image, a letter of the alphabet may be perceived, materialized literally by ink materials beginning with that letter, yet plainly made of mere ink. To draw the form of a letter from the image, a mixture of the ink materials contained within the frame must be made by the conceptual act of reading. Like inkblots, which ask the subject to draw meaning from material, this alphabet of ink does not function to illustrate the text (or even the letters themselves) but rather to act as a stimulus operating between concepts, connotations, and the ineffable qualities of ink as a medium, provoking the responses of the contributing authors and subsequent associations by the reader.

*ink* is structured as an abecedary, an easily recognizable form (ABC book) if an unfamiliar term, which may act as both a primer and a poetic form. As a "practice book," the abecedary is uniquely suited to an exploration of ink in architecture; and with precedents ranging from the ABCs of a subject's instruction—its first principles, essentials, or rudiments—to its highly sophisticated use by artists (Apollinaire, John Baldessari, John Cage, David Hockney, Jasper Johns, Gyogy Ligeti, Henri Michaux, Ed Ruscha), architects (F.T. Marinetti and Moholy-Nagy), art critics (Barbara Rose and Ellen Lupton), and philosophers (Bertrand Russell and Gilles Deleuze), it is particularly fitting as a structure for the contributing authors' broad range of voices. The abecedary foregrounds the material aspects of language, the mysterious area in poetry between a word's form, sensory perceptions, and their interaction with underlying meanings, yet the abecedary acts conceptually as well, as mnemonic device, or to cognitively encourage analysis and promote abstraction.

Provocatively, this room full of ink—as material, representational, and even spatially constructive of its architecture—may imply the extent to which any architecture may be considered to have an ink component, and by which ink can be considered as an indelible part of architectural space. The depth and resonance produced by subtle coincidences across the contributors' diverse entries has astonished me. As a collective experiment in pareidolia, the collection of responses constructs an open history of ink, one that is more provocative than conclusive. Like the ink itself, I hope *ink* may act as a medium to manifest thought in the future.

**Michelle Fornabai**

A is for Asemic writing adumbrated by artists.

B is for Blots that bemuse and bewilder.

C is for Carbon constructing contracts and calligrams.

D is for De-inking dubious doubts in a drawing.

E is Edible or Electrophoretic, eaten or eyed.

F is for Fingerprints fashioned from fountain pens.

G is for Gall whose genius goes ghostly.

H is for Hatching, handy for halftones.

I is for Ideograms, invisible or indelible.

J is for Jets that jauntily jot.

K is key in CMYK.

L is for Lines, leaden or lettered.

M is for Marks marked out on mylar.

N is for Nibs nested neatly in notation.

O is for Obscurity occasioned by octopi.

P is for Pockets protected, projective, or poché.

Q is for Quills quivering in quarrel and query.

R is for rationalizing by Rapidograph and ruling pen.

S is synonymous with soot, smoke, smudges, stains, and strokes.

T is for Technical, traced by technique, typified in typewritten tones.

U may be unexpected, unreal, unconscious, unreasonable, or unintelligible.

V is for Vermilion as described by Vitruvius.

W is for watery Wells within woodwork and words.

X marks the spot.

Y is for inky yielding an inkling.

Z is for Zaps and zings of Zip-a-tone.

## 104 Hidden Ink Objects

allography, alizarine, animal glue, aphasia, asemic writing, autograph, ballpoint, Bic, Biro, blot, blotter, bonestroke, brayer, brush, (ink)cake, calligraphy, carbon black, charcoal, China ink, coal, concrete poetry (calligram), construction documents, conductive ink (functional ink), cork, cursive writing, de-inking, diamond tip, drawing, edible ink, electrophoretic ink, felt tip pen, fingerprint, fountain pen, (iron)gall, gel pen, graphite, halftone, hatch marks, (ink)horn, ideogram, indelible ink, India ink, invisible ink, (ink)jet, cmyk, Letraset, letter, letterpress, line, line weight, lithol rubine BK (magenta), mark, marker, Mylar, nib, octopus ink, (ink) pad, pareidolia, penmanship, plotter, plume, poché, pocket protector, (ink)pot, Pounce, printer's ink, quill, Rapidograph pen, reed, Rorschach test, ruling pen, security tag, slate, sloe, smoke, smudge, soak-stain technique, soot, spill, squid ink (sepia), stain, stamp, stencil, (ink)stone, stroke, sumi-e ink, tattoo, technical pen, thermochromic, tint, tone, tortoise shell, typewriter ribbon, u (grapheme), u (phoneme), vermilion, wash, walnut, (ink)well, woodblock, x (signature), inky, Zip-a-tone.

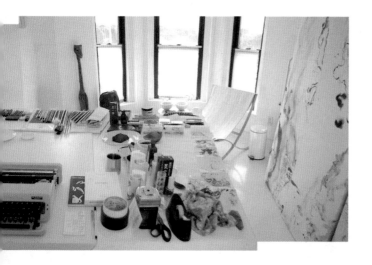

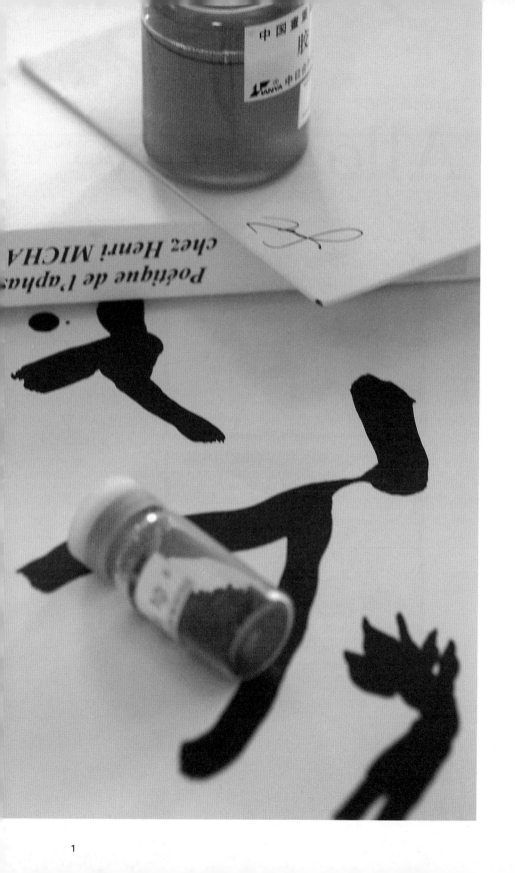

Poétique de l'aphas
chez Henri MICHA

中国畫
膠

Thom Mayne

# Allography

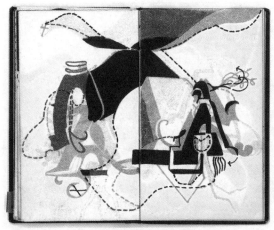

Allography: literally, "other writing." As a legal term, it means signing on behalf of another; in linguistics, iterations in the form of a letter (such as capitalized or lowercase, serif or sans serif); in phonetics, letters that are identical when spoken and different on the page. A single concept can have multiple authors, signs, and meanings operating concurrently, demonstrating the inherent complexity of locating authority.

Authorship is a powerful rhetorical position traditionally assigning control and decision-making processes to a single rational agent. This configuration is in many ways reductive and limiting; the creation of new forms is at odds with the idea of a priori modes of production. Techniques for disrupting authorship have been integral to modern art practice, relinquishing control in order to generate new forms and organizational systems. The implementation of contingencies—as in Jean Arp's grids of dropped paper, surrealists' experiments in automatic writing, and Pollock's gestural flinging—liberated compositional possibilities and informed future practice across multiple disciplines. The transformative power of these operational strategies lies in the active interplay of willfulness and chance that together form the basis for developing new forms of coherency. Rather than the imposition of a predetermined idea onto a material, authorship becomes dispersed through an active exploration of material possibilities and modes of representation.

## Henri Michaux

# Allography

As for living creatures and things, who has not wished to get a fuller, better, different grasp on them, not with words, not with phonemes or onomatopoeias, but with graphic signs?

Who has not wished at some point to create an abecedarium, a bestiary, or even an entire vocabulary, from which the verbal would be entirely excluded?

What if I tried my hand at it once again, opening myself in earnest to the creatures of the seen world?[1]

## Jason Payne

# Animal Glue

Animal Glue (and Art History)

What would it mean if colors would not cohere, if pigments refused to coalesce, if the categorical hues of our world—red, green, blue—simply *came apart*? This unnerving possibility seems to lie at the heart of the history and practice of the use of animal glue in representation. Anthropologists suspect that the first use of this now-obscure substance was likely by Neanderthals more than 200,000 years ago as a means to protect paintings from moisture, among other uses.[2] Later, various peoples used such adhesives to bind pigment and preserve drawn and painted imagery against natural decay. To us, now, this seems quaint: a primitive effort to stave off the inevitable fade of time upon the earliest impulses toward art rendered on, for the most part, pre-canvas surfaces having little to do with museums or architecture. But imagine yourself in their place and time, prior to indelible ink, and consider the horror that would ensue upon witnessing your very palette coming apart! Ancient artists were surely driven by the same motivations as their modern counterparts, so the notion that one's view of the world would quickly disassemble upon representation would be, at the very least, troubling. Like a bad trip, a painting that falls apart in real time for lack of a chemical binder would surely bring on bouts of anxiety and ensuing concern for the stability of things. The real world, after all, is what continually changes—not its

static, two-dimensional representation. Without animal glue, drawing and painting could never have emerged as practices so central to human sociocultural evolution, for without animal glue, drawings and paintings would disassemble nearly as rapidly (relatively speaking) as they were created. This is no conceptual hyperbole: without a binding agent, inks and paints literally—chemically—come apart and quickly disappear. Without animal glue—protein colloids formed by heating the bones and tissues of horses, deer, bovines, and certain fish—there would be no art history.

Zhang Xu

# Asemic Writing

Peach-Blossom River

A bridge flies away through a wild mist,
Yet here are the rocks and the fisherman's boat.
Oh, if only this river of floating peach-petals
Might lead me at last to the mythical cave![3]

Gilles Balmet—translation by Nanette Fornabai

# Blot

Les œuvres sur papier et toile que je crée depuis plusieurs années recourent de manière récurrente aux taches d'encre. Dès 2004, j'ai utilisé les possibilités de projections mentales qu'offrent les taches d'encre rendues symétriques par le pliage d'une feuille de papier au travers de la série *Untitled* (*Rorschach*), d'abord développée avec de l'encre

puis poursuivie avec de la peinture glycérophtalique sur toile. Au cour du développement de mes recherches, je me suis servi de l'encre sous diverses formes et elle a pu être tour à tour utilisée pure, mélangée, diluée en lavis, se retrouver transférée directement sur du papier, déposée sur des bâches en plastique au sol, dans des récipients divers et des piscines pour enfants disposées au cœur de mon atelier, liée à la peinture acrylique ou bien encore mélangée avec des encres d'autres pays après mon séjour au Japon. Elle peut aussi dans mon travail être propulsée en gouttelettes, absorbée par des mouchoirs en papier puis diffusée à nouveau après humidification, accompagnée vigoureusement par le souffle d'un aérographe ou encore dissoute par un pulvérisateur servant à arroser les bonzaïs. Cette encre a aussi pu faire du hula hoop à la surface d'une série d'œuvres du même nom ou glisser sur des petites billes de plastique à la surface de feuilles de papier d'un blanc éclatant.

Tous ces procédés de dessin que je développe par l'expérimentation visent à créer des taches ou des éléments graphiques plus ou moins contrôlés par ma maitrise et qui seront par la suite modifiés, retravaillés en fonction du protocole de travail développé pour chaque série d'images. Mon travail vise donc à sonder la maitrise que l'on peut avoir de phénomènes aléatoires comme la circulation de l'encre à la surface de supports divers. L'encre et les taches qui composent mes dessins stagnent parfois plusieurs semaines dans mon atelier dans des bacs en attendant d'être utilisées, comme dans un laboratoire photographique. L'encre semble parfois se cristalliser, et j'enregistre alors directement les effets produits par cette encre, comme des empreintes de phénomènes naturels, sur des feuilles que j'accroche à des fils tendus. Ces accrochages soumette alors à la gravité les éléments qui composent mes images, souvent situées à la frontière de l'abstraction et de la représentation paysagère. C'est notamment le cas avec la série *Ink Mountains* et les séries qui en dérivent telles *Reliefs*, *Paysages doubles*, ou *Paysages aux quatre horizons*.

Ces œuvres utilisent des mélanges d'encre de Chine diluée en lavis et de peinture acrylique en bombe de couleur noire, contenus dans des cuves ou des piscines pour enfants. Ces récipients pratiques dont j'ai détourné l'utilisation pour en faire des outils de mon travail accompagnent chacune de mes manipulations et sont utilisés en fonction de la taille des supports. L'encre et les taches d'encres agissent donc comme un véhicule pour la peinture acrylique. Dans ces mélanges de matières sont progressivement trempées des feuilles de papier, par des gestes sensuels et très maîtrisés qui tente de conditionner la répartition du mélange d'encre et de peinture à leur surface. La technique que j'ai développée petit à petit s'inspire de celle du papier à la cuve, utilisée dans la reliure ancienne ou celle du papier marbré. Il s'agit de jouer avec l'opposition de matières aqueuses ou grasses, qui se repoussent. Mais ici l'image, au lieu d'être purement abstraite, évoque des paysages dont les multiples étapes de la plongée de la feuille de papier constituent autant de strates. Je tente de jouer sur leur positionnement afin d'amplifier la dimension "photographique" du résultat de mes manipulations. Les différents niveaux de gris de l'encre et les dépôts sédimentaires de la peinture acrylique viennent préciser l'image et donnent de nombreux détails à cette image ambigüe, si

proche d'une photographie de paysage. Une nouvelle étape dans mon travail a été la création des *Silver mountains* et des *Silver reliefs*, sorte de mise en négatif de mes expériences précédentes, et cette fois sans encre, mais simplement à l'aide de peinture argentée se déposant par strates grâce à mes gestes sur des supports en papier noir, matériaux amplifiant encore l'ambigüité photographiques de ces œuvres peintes évoquant des paysages.

The works on paper and canvas that I have been creating for several years recurrently reveal inkblots. Since 2004, I've utilized the possibilities of mental projections offered by inkblots rendered symmetrical by the folding of a sheet of paper, reflected in the series *Untitled (Rorschach)*, which was first developed in ink, then followed by glycerophtalic paint on canvas. Throughout the development of my research, I've used ink in diverse forms and, in turn, have used it undiluted, mixed, washed, directly transferred onto paper, deposited on a plastic tarp on the ground, in diverse containers and kiddie pools placed in the center of my studio, tied to acrylic paint, or even mixed with inks from other countries after my stay in Japan. In my work, ink has also been flung in droplets, absorbed by tissue and then diffused again after dampening, vigorously accompanied by the breath of an airbrush, or even dissolved into a spray bottle used to water bonsai trees. This ink was also able to do hula-hoops on the surface of a series of works by the same name or glide along small plastic balls on the surface of brilliant white sheets of paper.

All of these processes, which I have developed through experimentation, aim at creating blots or graphical elements more or less controlled through my own skill, which are then subsequently modified, reworked according to the process developed for each series of images. My work aims at probing the mastery that one can have of random phenomena, like the flow of ink on the surface of a variety of media supports. The ink and the blots that make up my drawings stagnate sometimes for several weeks in my studio in trays waiting to be used, like photographs in a darkroom. The ink sometimes seems to crystallize, and I can record the effects directly produced by the ink, like imprints of natural phenomena, on sheets of paper that I hang by taut wire. These hangings then submit to the gravity of the elements that compose my images, which are often situated at the border between abstraction and the representation of landscapes. This is notably the case with the *Ink Mountains* series and in subsequent series derived from these works, like *Reliefs, Paysages doubles*, and *Paysages aux quatre horizons*.

These works make use of mixtures of China ink dissolved into washes of acrylic black aerosol paint, contained in vats or in kiddie pools. These practical storage containers that I have misappropriated as tools of my work accompany each of my manipulations and are used according to the size of the support. The ink and inkblots then act as a vehicle for the acrylic paint. Into these mixtures of

material, sheets of paper are dipped progressively with sensual and very controlled gestures that try to condition the distribution of the mix of ink and paint on their surface. The technique that I gradually developed is inspired by papers made by hand, used in antique bookbinding and in paper marbling. It's about playing with the opposition of aqueous and oily materials, which repel one another. But here, the image, instead of becoming purely abstract, evokes landscapes in which the sequential dips of the paper constitute so many strata. I try to play with their positioning in order to amplify the "photographic" dimension of the result of my manipulations. The different levels of gray in the ink and the deposits of sediment in the acrylic paint come together to clarify the image and to give many details to this ambiguous image, so close to a photograph of a landscape. A new phase of my work emerged in the creation of the *Silver Mountains* and the *Silver Reliefs* series, which constitute a sort of negative to my previous experiments. This time without ink, but simply with the support of silver paint settling into strata by means of my gestures on the medium of black paper, material amplifies further the photographic ambiguity of these painted works in evocative landscapes.

Chiang Yee

# Bone Stroke

We have four terms to describe the quality of strokes: Bone, Flesh, Muscle, and Blood. For we look at strokes and characters from an animistic point of view. [...] Thus every type of stroke should have a bone within it, formed by the strength of the writer. We criticize calligraphy according to whether it has strength—"bone"—or not. That is why the handling of the brush is of such importance. [...] The flesh of the stroke depends upon the thickness of the brush-hair and the pressure or lightness of the writer's touch. It also depends upon the amount of water in the ink. The flesh will be loose if there is much water, and arid if there is too little; it will be fat if the ink is very thick, lean if the ink is very thin. The nature of "muscle" in a stroke can be left to the imagination; when the stroke is bony and has the right amount of flesh, muscle is sure to be there. In well-written characters there seem to be muscles joining one stroke to another, and even one character to another. The "blood" of a stroke depends entirely upon the amount of water with which the ink is mixed—the color. Thus it can be seen that the principle of "life" is borne out even in the technical detail of Chinese calligraphy.[4]

Qin Feng—translation by Sarah McNaughton

# Brush

工具改变了历史, 也改变了历史的衍进, 结构以及文明特微。澳洲上世纪下半叶发现一族群仍生活在旧石器时代与东方文明相差数万年。同一星球, 时空阻隔了人类文明的异同进化形态与气象。

工具的演化和应用也改变了区域文明的特征和族类文化风貌, 如欧洲原古岩画与古典壁画至现代绘画有一脉相承之妙, 只是媒介与技术略有不同。彰显宗教、文化、艺术、科学等特微。

东方文明数千年飞速衍进, 唯独记录了它的工具 (毛笔) 仍保留着最原始的特征及功能 (小巧及文人情怀)。宗教精神与文明特微尽显笔端。

在此 (我) 改变了毛笔的形态 (如: 一拖把或其它, 只是完成我思想、意象和媒介的载体) 和功能 (或在完成一件作品后它已成为作品的部分)。它荷载了概念、语言和媒介, 又体现了本人思想及表达。偶尔也会在表现中转换为行为道具或形式语言中的符号。

毛笔—人类文明进程中活着的化石2012-03于北京

Brush—The Fossil of the Progress of Human Civilization

Tools have changed history; they have also changed history's evolution, framework, and civilizations. During the latter half of the last century, there was a group of people living in Australia that still lived as though they were in the Paleolithic era, several tens of thousands of years away from Western civilization. On the same planet, time and space have obstructed the pattern in evolution of the similarities to produce differences between human civilizations.

The evolution and the use of tools has also changed the characteristics of regional civilization and the features of racial culture; for example, Europe's original ancient cave paintings, classical murals, and modern painting all share a similar exquisiteness and ingenuity—just the medium and technique behind their creation are different. In today's art, aspects of religion, culture, art, and science appear.

Western civilization has rapidly evolved over several thousand years, yet one tool for recording it (the brush) still retains its most original characteristics and functions (it is small and exquisite, and it expresses the feelings of the literati). The religious essence and the characteristics of civilization reveal the artistic conception of painting.

Here I have changed the brush's shape (to, for example, a mop or something else; this completes the support of my ideas, imagery, and medium) and function (after finishing a piece, it has already become a part of the piece itself). It takes on the weight of ideas, language, and medium, while it also embodies thoughts and expression. Occasionally, through expression, it transforms into a behavioral prop or the symbol of the form of language.

ACI 309R-96

Guide for Consolidation of Concrete

...ng

onceptuel,
erspective

Conductive Carbon Paint, ...
M.E. Taylor Engineering, Inc...
301-975-9798 • Fax: 301-97...
...vent prolonged or repeated ...
...with soap & water. Cause ...
...s with water. Harmful if ...
...ate ventilation. MSDS is ...
Shake well before use.

art concel

Enrique Walker

# Calligram

```
SC
AF
FO
LD
IN
GS
```

IN AN INTERVIEW WITH GEORGES CHARBONNIER IN THE WINTER OF 1962, RAYMOND QUENEAU REFERRED TO HIS WORK THROUGH THE NOTION OF SCAFFOLDING. QUENEAU CLAIMED THAT, SINCE *LA CHIENDENT*, ALL HIS NOVELS HAD BEEN ORGANIZED UPON MATHEMATICAL STRUCTURES. THESE MATHEMATICAL STRUCTURES, HOWEVER, WERE NOT MEANT TO BE APPARENT TO THE READER. NOT UNLIKE SCAFFOLDING, FREESTANDING STRUCTURES THAT, ONCE REMOVED, LEAVE NO MARKS ON THE BUILDING WHOSE CONSTRUCTION THEY HAVE SUPPORTED, THE MATHEMATICAL STRUCTURES UPON WHICH THOSE EARLY NOVELS HAD BEEN CONSTRUCTED WERE MEANT TO DISAPPEAR AS SOON AS THE NOVELS WERE FINISHED.

TWO YEARS EARLIER, QUENEAU HAD CO-FOUNDED THE OUVROIR DE LITTÉRATURE POTENTIELLE, A GROUP OF WRITERS AND MATHEMATICIANS DEVOTED TO FORMULATING NEW AND UNEARTHING OLD LITERARY CONSTRAINTS, AS WELL AS TO PRODUCING LITERARY OBJECTS THAT WOULD SERVE AS EXAMPLES OF THOSE VERY CONSTRAINTS. QUENEAU EXPLOITED THE NOTION OF CONSTRAINT, SELF-IMPOSED AND AS A RESULT ARBITRARY, TO OPPOSE THE NOTION OF CHANCE, AS WELL AS REFUTE WHAT HE IDENTIFIED AS THE FALSE EQUIVALENCE SURREALISM HAD ESTABLISHED BETWEEN CHANCE AND FREEDOM. SO OULIPO MEMBERS ARE RATS WHO MUST BUILD THE LABYRINTH FROM WHICH THEY PLAN TO ESCAPE.

THE NOTION OF SCAFFOLDING WAS ARGUABLY DRAWN FROM, AND CERTAINLY IMPLIED BY, THE NOTION OF *CLINAMEN*, WHICH OULIPO INHERITED FROM ITS FORMER AFFILIATION WITH THE COLLÈGE DE 'PATAPHYSIQUE. CLINAMEN IS A S W E R WITHOUT A CAUSE. THE TERM WAS FIRST USED BY EPICURUS, AND LATER ELABORATED BY LUCRETIUS, TO DESCRIBE THE SPONTANEOUS DEVIATION OF ATOMS IN THEIR TRAJECTORY. ALFRED JARRY INCORPORATED THE TERM IN *GESTES ET OPINIONS DU DOCTEUR FAUSTROLL*, 'PATAPHYSICIEN, AND 'PATAPHYSICIANS TOOK IT ON AS A PRINCIPLE. FOR THE OULIPO, CLINAMEN IS AN ERROR DERIVED FROM THE USE AND MISUSE OF CONSTRAINTS FOR A LITERARY GOAL.

GEORGES PEREC DESCRIBED HIS NOVEL *LA VIE MODE D'EMPLOI*, HIS OULIPIAN MASTERPIECE, WHICH HE DEDICATED TO THE MEMORY OF RAYMOND QUENEAU, PRECISELY BY USING THE NOTION OF SCAFFOLDING. THE DESCRIPTION OF A BUILDING WHOSE FAÇADE HAD BEEN IMAGINARILY DETACHED AT 11 RUE SIMON-CRUBELLIER, IN PARIS, ON 23 JUNE 1975, AT ABOUT 8:00 P.M, *LA VIE MODE D'EMPLOI* YIELDS NO INFORMATION REGARDING THOSE CONSTRAINTS THAT PRECEDED, AND IN TURN TRIGGERED, ITS WRITING. THE CONSTRAINTS THAT PEREC VOLUNTARILY AND AS A RESULT ARBITRARILY IMPOSED ON HIMSELF TO WRITE THE NOVEL REMAIN, THOUGH AS A TRACE, OBSCURED TO THE READER.

ACCORDINGLY, PEREC FIRST UTILIZED CLINAMEN IN *LA VIE MODE D'EMPLOI*. FOR PEREC, CLINAMEN WAS AN ERROR DERIVED FROM THE PURPOSEFUL USE AND MISUSE OF CONSTRAINTS, WHETHER VOLUNTARY OR INVOLUNTARY, AN IDEA HE SUPPORTED BY REFERRING TO PAUL KLEE'S CLAIM THAT GENIUS WAS THE ERROR IN THE SYSTEM. THESE ERRORS BOTH EXPLOITED AND DAMAGED THE SYSTEM, AND, AS A RESULT, RATHER THAN MEANINGFUL, RENDERED THE SYSTEM OPERATIONAL. THE SCAFFOLDING IN *LA VIE MODE D'EMPLOI* WAS A SERIES OF RULES OF THE GAME FOR WRITING A BOOK. BUT THE RULES WOULD NOT DICTATE THE GAME OR EXPLAIN THE OUTCOME OF THE GAME: THE NOVEL ITSELF.

IN ARCHITECTURE, CONSTRAINTS ARE REQUIREMENTS TO BE MET. GENERALLY EXTERNAL, CONSTRAINTS ARE IMPOSED BY A BRIEF. DIFFERENT CONSTRAINTS CONVERGE WITHIN A PROJECT. AN ARCHITECTURAL PROBLEM STEMS FROM THE CHANCE ENCOUNTER OF SEVERAL CONSTRAINTS, ALL OF WHICH USUALLY CLASH WITH ONE ANOTHER. SOMETIMES THAT ENCOUNTER IS TIGHT, AND MAY PREVENT ALMOST ANY DESIGN ACTION. SOMETIMES THAT ENCOUNTER IS LOOSE, AND MAY ALLOW FOR ALMOST ANY DESIGN ACTION. SOMETIMES THAT ENCOUNTER IS PREDICTABLE, AND MIGHT LEAD TO A RECURRENT SOLUTION. SOMETIMES THAT ENCOUNTER IS UNEXPECTED, AND MIGHT LEAD TO AN UNFORESEEN FINDING.

AN ARCHITECTURAL PROBLEM IS NOT AUTOMATICALLY GRANTED BY THE CHANCE ENCOUNTER OF CONSTRAINTS, BUT IN FACT STRATEGICALLY FORMULATED BY AN ARCHITECT ON CLOSE EXAMINATION, AS WELL AS NEGOTIATION, OF THOSE VERY CONSTRAINTS. THEIR ENCOUNTER, THOUGH, IS OFTEN PREDICTABLE, AND LEADS TO RECURRENT PROBLEMS AND SOLUTIONS. CONVERSELY, CONSTRAINTS MIGHT BECOME SOURCES OF INVENTION WHEN THEIR ENCOUNTER IS, ON THE ONE HAND, UNEXPECTED, WHEN THEY DO NOT EASILY ALLOW FOR RECURRENT SOLUTIONS, OR WHEN THEIR ENCOUNTER IS, ON THE OTHER, CALIBRATED, WHEN THERE IS ENOUGH ROOM TO MOVE, THOUGH ALSO NO ROOM TO MOVE ENOUGH.

GIVEN THE ABUNDANCE OF CONSTRAINTS IN THE PRACTICE OF ARCHITECTURE, AND THE ASSUMPTION THAT PROBLEMS ARE GRANTED, RATHER THAN FORMULATED, CONSTRAINTS HAVE, WITH FEW EXCEPTIONS, BEEN EITHER DISMISSED AS OBSTACLES TO THE IMAGINATION OR ACCEPTED AS REQUIREMENTS TO BE MET. SOME ARCHITECTS ADVANCE CONCEPTS AND IN TURN STRIVE TO MEET THE CONSTRAINTS. OTHER ARCHITECTS MEET THE CONSTRAINTS AND IN TURN STRIVE TO ADVANCE CONCEPTS. IN BRIEF, SOME FAVOR THE FORMULATION OF ARGUMENTS AND NEGLECT THE RESOLUTION OF CONSTRAINTS AND OTHERS FAVOR THE RESOLUTION OF CONSTRAINTS AND NEGLECT THE FORMULATION OF ARGUMENTS.

IF CONSTRAINTS ARE EXTERNAL, SELF-IMPOSED CONSTRAINTS ARE INTERNAL. THAT IS, VOLUNTARY AND THEREFORE ARBITRARY CONSTRAINTS INTRODUCED TO INSTIGATE AN UNEXPECTED ENCOUNTER OF INVOLUNTARY CONSTRAINTS, TO REALIGN AN EXPECTED PROBLEM. SELF-IMPOSED CONSTRAINTS ARE ARBITRARY REGARDING GIVEN REQUIREMENTS, AS THEIR INCLUSION BEARS NO RELATION TO THE PROJECT, BUT NOT ARBITRARY REGARDING THE FORMULATION OF THE PROBLEM, AS THEIR INCLUSION SEEKS TO RELEASE POTENTIAL FOR THE PROJECT. IN OTHER WORDS, SELF-IMPOSED CONSTRAINTS ARE A SUPPLEMENT FOR CALIBRATING INVOLUNTARY CONSTRAINTS, AND IN TURN DIVERTING A BRIEF.

SELF-IMPOSED CONSTRAINTS ARE AGREED AT THE OUTSET, BUT DO NOT ENTAIL AN *ORIGIN* OR A *SECRET*. IN OTHER WORDS, THEY ARE NOT PRINCIPLES THAT PRECEDE, AND ARE EXPECTED TO INFORM, AN OBJECT, OR MESSAGES THAT PRECEDE, AND ARE EXPECTED TO REMAIN WITHIN, AN OBJECT. INSTEAD, SELF-IMPOSED CONSTRAINTS ARE HURDLES TO BOTH. AS OPPOSED TO THE FORMER, A CONSTRAINT PRECEDES BUT DOES NOT DICTATE THE OBJECT. AS OPPOSED TO THE LATTER, A CONSTRAINT PRECEDES BUT DOES NOT EXPLAIN THE OBJECT. THUS, SELF-IMPOSED CONSTRAINTS ARE TOOLS OF DEFAMILIARIZATION. LIKE SCAFFOLDING, ONCE EMPLOYED, THEY LEAVE NO MARK ON THE BUILDING.

Xu Li

# Calligraphy

小云山图卷

手卷是中国古代最为重要的书法表现形式之一。当然, 它的内容也可以是绘画。它展现内容的手法, 在视觉上显现出一种迷人的不确定性, 书法尤其如此。园林在中国的古典空间形态里, 也有类似的情况。它的空间布局完全随地形的具体形态铺陈开来, 建造的结果如同自然形成, 所有的空间要素都有精神的隐喻, 这完全不同于简单的空间符号的设计。

我所实践的嘉园, 位于中国最古老的江南城市之一——苏州。它拥有世界上最多也最复杂的中国园林形态。嘉园设计的空间节奏感由轻柔到剧烈, 到激情, 复归恬淡。用书法的线条变化形式布置景物, 由淡墨, 浓墨, 泼墨, 到飞白, 再到淡墨收, 这是一篇书札, 我写给某个远方的友人, 这里包含山峦, 池塘, 沟壑, 山林, 花草, 屋宇, 还有亭台水榭。所有的空间都基于中国式书写的韵律和我内心对书法的虔诚。

这里移植了数棵几百年的老树, 堆砌着几百年前就被使用过的古老的石头材料, 无论假山或者青石地面, 他们都是书法中的宿墨与飞白, 然而, 正是它们的存在, 是这卷书法最有生命力量的表现。没有细节修饰的长廊, 回旋曲折, 但是不纠缠在一起, 因为, 中国的书法里需要空间的通, 园林亦是如此。

每当江南雨季来临, 园林周遭都是淡淡的雾气, 我想这可能就是梦境。一卷江南书法梦境。

## Hand Scroll of Lesser Clouded Hill

Hand scroll is one of the most important expressions for calligraphy in ancient China. A means to carry paintings, it conveys more than this simple function suggests. The way of expression of hand scrolls presents a charming visual uncertainty, particularly for calligraphy. Gardens present the same effect through classic spatial forms of China. Their spatial arrangement is fully extended following the specific outlines of the terrain, and they achieve architectural effects as if formed by nature. All the spatial elements embody spiritual metaphors, which remain distinct from a simple design of symbols.

The Jiayuan garden, where I carried out my practice, is located in Suzhou, one of China's most time-honored cities in the southeastern region, possessing the most numerous and complicated forms of Chinese gardens in the world. The spatial rhythm of Jiayuan unfolds from softness to intensity, to passion, and then returns to peace. These arrangements of scenery inflect the form

of my calligraphy, which starts from light ink to dense ink, splash ink, hollow strokes (flying white), and finally returns to the light ink. This is a handwritten letter from myself to a friend far away, which contains hills, ponds, ravines, forests, flowers and grass, houses and pavilions. All of the spatial arrangements are based on the rhythms of my heart and my inner devotion to Chinese calligraphy.

In the garden, some trees that are more than several hundred years old have been transplanted, while ancient rocks that had been used a few centuries ago are also piled up. Whether in forms of rockeries or stone pavement, they are like overnight ink (unused ink dried on the ink stone) and hollow strokes in calligraphy, and their life is the most powerful expression within the hand scroll. The unrefined long corridor circles around, it is not tangled but intertwined, as gardens also need special freedom as calligraphy does.

Once the rainy season in the southeastern region approaches, the garden is veiled in a slight mist. A dreamland I dreamed, a dreamland of calligraphy belonging to this special region.

Karla Rothstein

# Carbon Black (BONE BLACK, BONE CHAR)

*Carbon* is the elemental basis of all life. *Black* is the absorption of light into mystery.

Carbon atoms eagerly bond with one other and with 110 of the 117 other chemical elements of the periodic table to form the constituents of all naturally occurring matter. Structuring every cell of every living entity, carbon is the biological adhesive of life. The human body is roughly 18 percent carbon by weight, second only to oxygen in building the mass of our physical being. Remove the water from our bodies and brains, and what remains is almost entirely carbon.

Carbon is the living origin of fossil fuel—formed by ancient corpses—decomposed, layered, and compressed over time. Once-living carbon resides patiently in long-dead, fossilized plants and animals, slowly intensifying their carbon-ness as liquids (oil), solids (coal), or gases (natural gas). Even in death, carbon atoms maintain the energy and intensity of their bonds.

The tenacity of carbon bonds is broken through combustion or digestion, generating energy from both prehistoric organisms and living cells. Once liberated, carbon atoms are intensely attracted to oxygen; so intensely, that their preferred state is to unite with two oxygen atoms forming $CO_2$. The combustion of carbon-based fuels facilitates excessive C+O+O bonding, contributing to the precarious imbalance in our carbon-rich environment.

Structurally, carbon atoms seek to bond with up to four elements concurrently and exist in three distinct forms. Under immense physical pressure within a viscous layer of the Earth, carbon forms transparent, symmetrical covalent bonds, creating non-absorptive rigid tetrahedral networks, also known as diamonds. These monometric crystals are among the hardest naturally occurring substances known on Earth. Not only terrestrial, diamonds have been found in meteorites and compose one entirely crystallized, exceptionally dense planet, shimmering 4,000 light-years away from Earth.

A second, more quotidian form of carbon occurs in the soft, dark, and lustrous opaque crystalline sheets of graphite. Smudging and smearing, yielding traces of externally applied pressure, graphite is absorptive, slightly conductive with a nearly black metallic luster. Though atomically constituted of identical carbon elements, the physical appearance of diamonds and graphite are near opposites.

And then there is amorphous carbon, different from its more pure and stable crystalline cousins, amorphous carbon is partially free, intractable, and reactive. This third form of carbon, obtained from smoky flames of burning bones or other organic materials, is unsettled and impure.

Animal bones, pulverized, heated, and charred at very high temperature in the near absence of oxygen, ooze unstructured carbon chemicals. This residue is the deeply saturated, insoluble black of "bone black." Produced through a process termed pyrolysis—here, decomposition accomplished by combustion induces irreversible chemical and physical phase changes simultaneously—smooth, dense, and fluid, bone black is the least pure form of carbon.

Technically, carbon-black is derived from fossilized carbon, and in some applications has replaced traditional bone-black. In the form of carbon-bone char, once living structures are transformed into ephemeral yet indelible smoke—the vital intensity of this near zero albedo pigment, bringing nonreflective presence to the absence of the life it once was.

Galia Solomonoff

# Construction Documents

Construction Documents are the written and graphic instructions used for the construction of a project. These documents strive to be accurate and consistent as they provide the basis for planning, cost estimating, and ultimately, building a project.

I stumbled upon a chain of artists' projects in 1996, when Fabian Marcaccio accepted a teaching position at the Skowhegan School of Painting and Sculpture in Maine. I was just out of architecture school, and this ten-week habitation in one of the most dynamic artists' colonies in the U.S. sedimented a belief in the continuities and differences between art and architecture. Most artists work in direct contact with materials and invent processes to manipulate, engage, hang, install, frame … . I consider materials and methods in a procedural way. The mental distance of the architect to matter necessitates a premeditated coolness to compile inked instructions for making, or Construction Documents.

In the studios and shops, I observed painting and sculpture in the making; the artists saw how I thought at an architectural and urban scale. Within that summer a few exchanges occurred, artists would make a sketch and I would help them turn these sketches into an instruction set for the construction of a larger installation. While the starting point was often not my work, it became my work as I helped figure out how to construct it. My first building from the ground up was the directors compound at Skowhegan, designed and built in the summer of 1997.

After working for Koolhaas in Rotterdam, I formed OpenOffice, with Linda Taalman, Alan Koch, and Lyn Rice in 1999. OpenOffice was conceived as a flexible association assembled in response to specific projects. We embraced the idea of a plural collaborative practice—taking part in a generational shift in pre-millennial New York from the singular heroic and corporate practices to multidisciplinary collaboratives. We worked with Jorge Pardo (Dia 22 Street Bookstore 1999) and Jessica Stockholder (Public Art installa-

tion in Champs-Élysées, Paris, 2000), both artists associated with Dia. Michael Govan, the young director of Dia, contacted us through the recommendation of these artists.

Dia involved the conversion of a 292,000-square-foot Nabisco box printing factory along the Hudson River into a museum of contemporary art. Govan had designated artist Robert Irwin as master planner, and had convinced his board of directors to hire OpenOffice as architects. We began to work on Dia:Beacon in July of 1999. OpenOffice[5] worked closely with Robert Irwin, and with the living artists of the collection—Richard Serra, Michael Heizer, Walter de Maria, Louise Bourgeois, Sol LeWitt, Bruce Nauman, Gerard Richter, and Fred Sandback.

We became familiar with Dia's collection, consisting mostly of minimal, conceptual sculpture and painting of the 1960s and 1970s. Early in the process, Yehuda Safran said to us that we had to "Do nothing with absolute precision," and I took it to heart. Dia was facing the perfect museum dilemma as described by Irwin: a great forum for art runs the *risk of ending up* with a collection and becoming a museum. Dia had begun to accumulate a collection and was speculating about what to do with it. Govan made the decision to transform Dia into a museum with the help of Irwin. Irwin's dual role as artist and master planner was essential to Dia's transition into the museum phase.

Irwin was 71 when we started Dia:Beacon; he looked at the project as a phenomenological experience that had to be honed. His initial master plan presented the building as a singular plane, an extensive vision encompassing galleries, parking lot, and gardens. I was 32, our most important task was to facilitate, source, find, document every single thought and intuition that Irwin had. We did this with the infrequent devotion youngsters give to elders. In the beginning, our collaboration with Irwin was long distance and we were working on very different aspects of the building; he was coming to the building looking at the space between the material and we were looking at the material: the walls, the floors, the roofs. In 2000, Irwin moved to Garrison, New York, to be able "to run his hands over the place," and we started to meet frequently. Our role was as facilitators of the design; the design originated with Irwin, yet through us, it changed to become measured and specific.

James Schaeufele, Dia's director of operations, was instrumental in helping us transform Irwin's intuitions into a workable design. We learned a myriad of techniques from Schaeufele and his team of experienced installers. Their knowledge of painting, sculpture, and construction was key in devis-

ing not just a material palette but also in developing methods for compiling sequences and delineating details, which I still use every day. This setup required patience to process the workload, and an ability to resign credit at every turn.

When much of minimal art was made in the 1960s and 1970s, there was a questioning of the places in which art was shown—the museums and galleries— and the circumstances under which art was produced—the ateliers and studios. Artists moved into former industrial buildings in Soho and Tribeca and transformed these spaces into live/work lofts. In turn, these spaces inspired a rethinking of the relationship between the work created and the spaces the work was created in. Within the tradition of performance and happenings, artworks were created that were active within the gallery space, destroying its assumptions of neutrality. Richard Serra's lead *Splash Piece* asserted that the gallery space was not only essential to the work's presence, but as its mold, inseparably part of it.

The spaces at Dia:Beacon, and the spaces I continue to create, are not neutral—they could not receive just any art or activity. Over the years we have devised a series of recurrent details in tune with a vocabulary of materials. Like many, I believe that the materials one uses and the techniques one employs determine the architectural form one gets. There is a right way of building with bricks, and a wrong way of pretending to use them. With digitalization and industrial production, building materials have become thinner and are often coated with plastic shields to defend them from wearing. One can shave marble thinly. A room in Vegas can be done with much less material than a room the same size in ancient Rome. The material appears the same, yet it is not, and the joints and the ink of the construction documents reveal the story.

As the raw becomes more rare in our environment, and smooth plasticized surfaces appear everywhere, the raw—in weathered steel, untreated oak, or brick walls—calls attention to its materiality in space and over time. The "raw" becomes present through its refinement in ink—in the drawn lines of details, and in the textual lines of material specifications. Everything looks good when new and young, the trick is to look noble after a long useful life. Handcrafted things age better than things cut by machine, because craft relates to our bodies in a more profound way. We prefer the gestures of craft and we use them in dialogue with the gestures in art. We tweak details to work with the flow and rhythm of each particular space, to bathe in particular light conditions. Repetition, rhythm, and ready mades are used to imbue a space with calm presence. A finished drawing, most often a reflected ceiling

plan, shows in the ink markings the rhythm of the space. If it feels too punc-tuated—a chandelier in the wrong spot, odd bays instead of even—we review it again and look for ways to attenuate the presence of the salient elements. With surface we do the same thing. We look for a rhythm that is confident yet feels like background.

Our general aim is to disappear, and to make art and building as one. We believe our strength as architects is a stealth active presence (like a good mother, neither neutral, passive, nor distractive), which remains discrete, structural, and attuned while sustaining a tension with the works, and making space grow over time. To make space, we opt to use every material, tool, and stroke in a premeditated, controlled, cool way. The aim to disappear requires precision above all; the markings need only be where they need to be. Over time we get closer to getting it right, the aim is not perfection but intimacy with the elements of space and time.

Yehuda E. Safran

# Cursive

In Chinese art, a traditional aesthetic ideal exists called "The Three Perfec-tions," which refers to the fusion of poetry, painting, and calligraphy. Here in the former industrial site Renault, Ile Seguin-Rives de Seine in the west of Paris, we are presented with something comparable, a multimedia project by the Marie-Laure Cazin in collaboration with Laurent Piron.

In this singular work, a moving series of images is interspersed with a text whose calligraphy in ink, is subject to constant fluctuations in tem-perature, so that the overall effect is one of extreme elasticity. The images are embedded in the glass façade of the recently completed Hines' Office Building designed by the office of J.P. Viguer. As for the texts themselves, they are digitally mediated reproductions of ink originals, imbued with specif-ic thermo-chromatic qualities; this makes any changes in the external atmo-sphere immediately visible, fugitive, almost palpable, and at the same time quite conspicuous.

Due to these technical expedients, Cazin has created a composition in constant flux. It is a well-nourished dream of our childhood to be able to see,

to make visible that which precisely defies the eye. Who has not experienced Pinocchio's dream, in which the size of one's nose indicates the enormity of the lie that has just been told, or the sin that has just been committed?

Serigraphy makes the images animating the narratives appear to be the daily events of an office, but with a difference. They are affected by the ephemeral quality of the texts, which at each moment matches the movements of a corresponding image. In this way they acquire the character of the surrounding circumstances. We are therefore presented not merely with a narrative, or a mere illustration of a text, but with something more like the calligraphic inscription in Japanese characters. Through this shifting medium we are told of animals in a garden whose individual songs fuse in a concert that sings of their imminent disappearance. Every word on the glass becomes a voice; in the autumn, wind could have sung the same song.

Before and after, around each word, monad-like, the infinite distance envelops the images and texts that only a leap of faith can bridge. Of course, letters and words exist independently of the ink and even of the written words. And yet, who could fail to register the curve of a line? Indeed, the imagination of rhythm inspires the rhythmic movement of the body, which intimately determines the use of language as much as it conditions everything else. This intervention in the façade of the Hines' building is without precedent; it offers the passerby a repetition in the imagination without which one can never be fully alive. It does not merely supplement the existing building but negates its inertia. It invites the spectator to become aware of his, or her existence, which suddenly acquires an unanticipated dimension. We rehearse our lives among works of art, which we have encountered. For many would-be spectators of this façade variable, this will be their daily bread of art.

Ever since Francis Bacon refigured the open mouth seen in Sergei Eisenstein's films, painting has had no choice but to take on the logic of the cinematic perspective, and montage became the norm. A new logic of sensation has come to prevail all the more for recent generations for whom the work of art par excellence is the cinema. Cazin has realized once again a film without a camera. The imperfect image, numeric, digitally manipulated, has become her paradigm as can already be seen in such works as in *Les histoires de la tache I* that lasted ten minutes (2003). In more recent film: *Tarentelle*, a work in progress, she described as a "cine-concert." Our perception of the image is in this respect conditioned by the sound; the film becomes elastic in the sense that the speed of images, colors and luminosity is variable and extended in relation to the sound.

In this *façade variable* she seems to echo Ezra Pound's words in *ABC of Reading*: "poetry begins to atrophy when it gets too far from music" and

"music begins to atrophy when it gets too far from dance." Created with ink on glass, the calligraphy does not merely supplement these images and graphic shapes but animates the entire sequence. Just as in the dance that moves through space-time, the viewers can respond to the artist's fingers, hand, arm, mind, heart, and body, and ultimately share the special and particular energy that informed and suffused this work.

The varieties of scripts and touches enable the *façade variable* to become not only the artistic record of personal character and individual expression but also a rich screen of projections and reflections. The experience of viewing this work is much more like the experience of music than anything else. Its faster and slower tempi, stronger and gentler touches, wetter and drier textures, and even louder and softer tones move us to perceive and experience comparable qualities in ourselves. The choreography of line and form in space is more immediately perceived as we move ourselves. It is this sense of movement, ultimately of dance, that gives life to this montage.

Written from top to bottom in columns from left to right, move down the column, and then return up to the top of the second column. The movement is primarily vertical and horizontal. It is quite different from the horizontal path of our expectation. In addition to the movement forward and backward as a result of fading and increasing intensity, we are presented with a dynamic simultaneity. This reminds us of an obvious fact often taken for granted, namely that within the range of Western alphabets there are a great variety of letter forms and several scripts. The cursive script suggests quicker and less formal writings (which is what we usually practice ourselves for everyday use) to fully cursive script (when we are in a hurry and continue from letter to letter without lifting the pen or pencil from the paper). The latter can be difficult at times to read, even with only twenty-six letter possibilities.

The interaction of movement and pause, energy and stillness gives the completed work its life-breath. Thus we begin at the top left, move down the column and to the right as one always does in the West. The choice of cursive script has a much more fluid and rapid feeling. By using the script deliberately against image and format, something new is expressed—it influences the total artistic expression of the work. Combined with the gestural action of the writing itself, created with a flexible line that responds to the artist's pulse of breath and movement, the result is an art that is comparable to the calligraphy, which has been long admired in East Asia.

Each one of us carries a dream of a total film which he/she wishes he/she had realized, better still, lived. In this *Façade Variable*, Marie-Laure Cazin and Laurent Piron travel a considerable distance to make this dream a reality.

Daisy Nam

# Diamond Tip

Tools are critical in our cultural life. With them, we are able to transform an idea and to externalize it. Through them, we can create something that communicates and engages with others. There are myriad ways the diamond tip is used in art, technology, and even in pop culture. Here, I list the most curious findings that have given me a kaleidoscopic view of the world, allowing me to see and think a little bit differently.

*Drypoint* is a type of print in which a metal point is scratched into the surface of a copper plate. When a diamond-tipped needle or scribe is used, a burr (or ridge) on each side of the line is created. The plate is coated with ink and the excess ink is then removed. A soft line is printed from the burr that catches the ink, which creates a velvety effect. The diamond point has an advantage to the steel tip in that it can move in any direction and at any angle, creating fluidity in the lines.

The diamond-tip cuts through *"like a knife through butter."*[6] A key part of artist William Kentridge's practice since the 1970s has been printmaking. Kentridge prefers the diamond-tipped tool when working in drypoint, as it allows him to move quickly in a way similar to drawing or drafting, but more gracefully. This freedom of movement is important to his improvisational way of working, as "the activity of drawing is a way of trying to understand who we are and how we operate in the world."[7]

In Whit Stillman's *Barcelona* (1994), American ex-pats Fred and his cousin Ted, nicknamed "Punta de diamante," navigate social circles as they try to find love in a foreign city. We discover the complexities of identities as well as perceived and projected cultural stereotypes. A conversation with Fred and Spanish girls at a disco about his cousin Ted:

> Fred: "He's a complex and in some ways dangerous man. He has a serious romantic illusion problem. Women find him fascinating. His nickname is *'punta de diamante,'* point of a diamond."

Woodworker, furniture maker, and architect George Nakashima was known to have used a diamond-tipped cutter to saw misshapen burls (the outgrowths found on tree trunks), when crafting a piece of furniture. He treasured these knotted formations, as he believed they possessed *the tree's soul*. The diamond tip allowed him to saw these forms with great precision, thereby preserving the hidden histories of the tree in a new form for man's use.[8]

WASP-12b, a planet 12,000 light-years away from Earth, is the first carbon-rich world ever observed. In 2010, the Spitzer telescope discovered WASP-12b as the first planet to have a carbon-to-oxygen ratio measuring greater than one. NASA Astronomer Marc Kuchner observed, "If something like this happened on Earth... *the mountains would all be made of diamonds.*"[9]

In the immensely popular online role-playing game *World of Warcraft*, characters controlled by players complete various missions while developing skills. In exchange for completing missions, points, items, and game money are given. A character can acquire the "*Diamond-tipped Cane,*" a two-handed weapon with a bright sparkle. Although the actual use is debated, based on its statistics it may be presumed that the cane's primary purpose is cosmetic.[10]

Wendy Jacob

# Edible Ink (WITH CAUTION)

The Inky Cap Family, genus *Coprinus*, is one of the most common varieties of urban mushrooms and can be found growing in thick clumps at the base of trees or scattered across lawns. The family gets its name by its habit of autodigestion. When it reaches maturity, the Inky Cap destroys itself with its own enzymes, dissolving into gorgeous, gooey, black liquid.

Medieval monks made a fine-quality writing ink by boiling the deliquesced caps with cloves.

My mother makes a delicious soup by cooking quantities of Inky Caps with butter, a little onion, cream, salt, pepper, and nutmeg. Because the caps start to liquefy within hours of picking, she also uses them for making gravy and in beef Stroganoff, where it doesn't matter if they don't hold their shape.

Gary Linkoff, author of my trusted field guide to North American mushrooms, rates the edibility of the Inky Cap Family from "unknown" to "choice." One of the family members, *Coprinus atrementatian*, gets a rating of "good, with caution." While the mushroom itself is not toxic, if it is eaten within one to two days of consuming alcohol it can cause flushes, palpitations, and vomiting. A good host will always inform her guests if it is included in a dish.

Kazys Varnelis

# Electro-phoretic Ink

Electrophoretic ink, or e-ink, is a display technology that seeks to supplant paper with a display made of ink sandwiched between thin layers of plastic, glass, or paper. These layers have electrodes applied to them and when charge is applied, the electrodes act upon white (titanium dioxide) or black ink (carbon black) pigments, attracting one while repelling the other. The resulting display has a similar appearance to paper since it uses traditional pigments as opposed to light to display information.

High in contrast, consuming little energy, requiring no backlighting, and permitting thin and flexible displays, electrophoretic ink displays suggest that one day we will leave behind the liquid crystal display just as we unceremoniously left behind the cathode ray tubes.

E-ink isn't just a display; it is part of a change in print culture as significant as the one created by the printing press. With the ability to be reconfigurable on demand, e-ink suggests that in the future we will no longer need pages or books, being able to access any knowledge we want with one page.

The current battles regarding copyright will one day end in the liberation of books from ownership, thus making any networked e-ink page a new Library of Alexandria.

But if we turn back to the printing press, we can see it not just as a means of distributing texts but also as a model for a revolution in culture through the introduction of standardization. Standardized type led to the mass production of objects, while standard languages accompanied the rise of the nation state and standardized imagery allowed architectural designs to lose their ties to local conditions.

As a digital technology, e-ink promises near-infinite flexibility. Although architects have responded to the potential of the computer with non-standard architectures, of near-infinite variation in form, this is merely a historical footnote. For the real promise of e-ink is the infinite flexibility of an object. Barring simple constraints—in the case of e-ink, that of size—the future is not of a hyper-specific

non-standard world of unique objects; it is of a world of generic objects with the capacity to be anything.

E-ink promises that we will not merely write books and tattoo the spaces around us; it presents a model for reshaping the world into anything. It is the universal spaces of Mies and Archizoom, not the specific spaces of Scharoun and Hundertwasser that define our futures.

Soo-in Yang with Peter Logan

# Functional Ink

> The printed book, the gnawing worm of the edifice, sucks and devours it.... It no longer expresses anything, not even the memory of the art of another time.
> —Victor Hugo

Ink, the very matter of the written word, replaced stone masonry as the building block of knowledge. The Renaissance cathedral with its frescoes, the Greek temple with its entablature, the Egyptian pyramid with its hieroglyphs were no longer the arbiters of knowledge. The printed word spread faster, was cheaper and could reach a larger constituency. If the book, and by extension ink, did indeed kill the edifice, then it will be the very venom that led to its demise that will ultimately resuscitate architecture as an important disseminator of knowledge, returning architecture to its abdicated throne. The antidote for the ills of architecture rests with the communicative possibilities of electronic and conductive ink as building materials.

Printed books, newspapers, and magazines are swiftly being replaced by digital mediums for storing and communicating knowledge. Digital sources are more democratic, often open source, and accessible across the globe via

an Internet connection through public domains such as Wikipedia and Google. There has been little synergy between this new form of knowledge and the built environment. Consumption of digital information has primarily involved the intimate and individual uptake of knowledge on personal devices. Times Square New York, possibly the most prominent example of publicly projected information, rather crudely employs an array of tacked-on devices to digitally communicate, becoming a gigantic, revolving stream of information with its ticker-tape news and static and animated electronic displays. Here you consume knowledge simultaneously with those around you. Here knowledge is a public commodity. Here it is part of the built environment. It is unique in these regards, one reason why it is such an iconic neighborhood. What if this public display of information could be painted into the genetics of architecture with electronic and conductive ink?

Conductive ink is composed of metallic nanoparticles—typically either copper or silver—which have lower melting temperatures than their bulk counterparts, allowing it to be painted or drawn on surfaces. It is commonly laid down just as an inkjet printer lays down traditional ink, most commonly on circuit boards. However, it can also be applied to a range of materials from glass to ceramics to polyester. The ink resists heat and moisture and is even stretchable to the extent that it can be printed on flat surfaces to be molded into other forms. Its flexibility and strength make it a promising building material in a digital age in which power cables have enslaved our electronics.

Electronic ink is conductive ink's complement. Popularized by e-readers as a material that can mimic the optical properties of printed text, electronic ink might not only replace conventional signage but also create a new dynamic, evolving interface with the public. The ink acts more like pixels on a digital display, so it can be updated to reflect new information. Yet unlike typical displays, electronic ink consumes very little energy and can be deployed on a flexible surface with similar material properties to paper.

Together, these advanced ink technologies have the potential to revolutionize how we publicly display information. Conductive ink could be painted or printed on façades, or any interior building surface. Electronic ink could be applied like wallpaper to almost any form. Designers are beginning to see the possibilities inherent in these materials to bridge the built world with the digital world in order to create synthetic, interactive experiences. Just as in the movie *The Matrix*, walls would be teeming with information, although without the dystopian future, of course. Ultimately, electronic and conductive ink could render our built environment *alive* with information, vanquishing the printing press once and for all.

Jane Austen

# Gall (IRON GALL INK)

To Make Ink

Take 4 oz. blue gauls, 2 oz. of green Copperas, 1 oz. of half of gum arabic, break the gauls, the gum & Copperas must be beaten in a Mortar & put into a pint of strong stale Beer; with a pint of small Beer, put in a little refin'd Sugar, it must stand in a chimney Corner fourteen days & shaken two or three times a day.[11]

Anthony Vidler

# Graphos

Introduced in 1934 as a controlled substitute for the traditional *Ruling Pen*, the *Graphos* Pen,[12] with its range of twelve different thicknesses allowed for the elaborate kind of *Hatching* beloved by Paul Rudolph and his followers. Introduced to the *Graphos* in 1960 by a follower of Rudolph, Peter Eisenman, then a graduate student at Cambridge, I was instructed to master the *Ruling Pen* before attempting to use the *Graphos*. The art was to vary the thickness of the line without incurring the dreaded *Blot* that was so difficult to erase on the preferred Whatman Creswic Hot Pressed paper without destroying the silky smooth upper surface and thereby making any line without fuzzy edges impossible to draw. The *Graphos* took some of the risk out of this operation, but in the process, one was told, lost some of the aesthetic aura (see Walter Benjamin) stemming from the variations in striation of the *Ruling Pen*. The *Graphos* then became the preferred drawing tool, and, as is the case today in using computer generated drawing to imitate hand drawing, one tried to emulate the *Ruling Pen*'s vagaries by the use of *Graphos* half-filled, then fully filled with ink. The result often created moiré effects of extreme beauty, similar to those developed through the use of small image sensors in digital cameras, but effects that destroyed the uniform play of light and shade on renderings of façades. Night after night, bent over beneath the hot light of angle-poise lamps,

one hatched and hatched as if willing the emerging drawing to develop a life of its own. Inevitably, the façade was unrolled for the review with only half its windows fully rendered, giving the design the look of a bombed-out building. Sections were more successful, along the lines of Rudolph's amazing sections of his New York townhouses, while perspectives (the example of the rendering for the Yale Art and Architecture Building was foremost in our minds) were easier as more "impressionistic." Mastering the art of changing nibs in mid-line, wiping the swiveled nib for de-incrustation, refraining from leaving the ink rag on the paper while leaning over the drawing, and aiming the pen at the wall and not the drawing while shaking for renewed flow were all aspects of the *Graphos* craft. It comes to mind that large quantities of plain chocolate digestive biscuits were consumed nightly *en charrette*.

## Denis Diderot—translation by Nanette Fornabai

# Hacher

Hacher, *en Grav. & en Dess*. est l'art de disposer des lignes à l'aide du burin ou du crayon, pour donner l'effet aux différens objets que l'on veut ombrer, soit en Gravure, soit en Dessein. Pour *hacher*, on se sert de lignes droites, courbes, ou ondées ; quelquefois on les employe seules, quelquefois aussi on les employe ensemble en les croisant en forme de losange, plus ou moins obliquement. Le sens dans lequel il convient de disposer ces lignes ou traits pour former les ombres, n'est pas tout-à-fait arbitraire, comme bien des graveurs & dessinateurs le pensent ; il faut que leur direction participe de la nature ou de la perspective de l'objet que l'on veut ombrer. Si l'objet est rond, le sens des hachures doit être circulaire ; s'il est uni, les hachures doivent être unies ; s'il est inégal, les hachures doivent participer de ces inégalités. Enfin pour parvenir à donner l'effet convenable, soit à une gravure, soit à un dessein, le grand art est de les varier, de maniere cependant qu'elles indiquent toûjours l'inflexion ou la forme générale des différens objets qu'elles couvrent. S'il y a plusieurs hachures les unes sur les autres, ainsi qu'il arrive le plus souvent, qui se croisent en maniere de losange ; il faut toûjours affecter que celle qui peut exprimer la forme générale ou particuliere de différens objets ombrés, soit la dominante ; ensorte que toutes les autres lignes ne servent que pour la glacer, l'unir, & en augmenter l'effet.[13]

Hatching, *in Engraving & in Design*, is the art of arranging lines with the chisel or the pencil, to give effect to the different objects that you want to shade, either by

etching or by drawing. To *hatch* one uses straight lines, curves, or wavy lines: sometimes they are used alone, sometimes they are also applied together by crossing them, more or less obliquely, into diamond-shaped patterns. The direction in which one composes the arrangement of these lines in order to form shadows is not entirely arbitrary, as many designers & engravers think; their direction must contribute to the nature or the perspective of the object you want shade. If the object is round, the hatches must be circular; if smooth, the hatches must be uniform; if uneven, the hatches must contribute to these irregularities. Finally, to achieve the proper effect, whether it be an engraving or a drawing, there is a vast art in varying the lines, the manner by which they repeatedly show the inflection or the general shape of the different objects they cover. If there are multiple hatches one upon the other, as happens most often, which intersect in a diamond pattern; one must always assign the one that can express the general or particular form of different shaded objects as the dominant one; ensuring that all the other lines are used only as the icing, to unify, and to increase the effect.

Roland Juchmes and Pierre Leclercq

# Hatching

La Hachure et l'Esquisse Numérique

La hachure est une figure paradoxale. Formée de traits, elle fait émerger une surface. Elle définit une forme en l'absence de son contour. La hachure ne s'offre qu'à un deuxième niveau de lecture. Quel peut alors être le statut de la hachure dans une esquisse numérique ?

 Schématiquement, deux questions se posent : l'identification de la hachure au sein du dessin (la segmentation du tracé en entités graphiques) et l'interprétation de celle-ci.

 La question de l'identification peut paraître facile au premier abord : une hachure est ensemble de traits proches et parallèles de longueurs similaires. Cependant d'autres entités graphiques répondent à cette définition : une cote contenant plusieurs « 1 » (111), un trait pointillé (_ _ _) ou encore le tracé d'un escalier. Tous ces objets qui nous semblent naturellement si différents peuvent être difficiles à identifier pour un système de reconnaissance. C'est le contexte, l'environnement graphique, qui va donner à un ensemble de traits le statut de hachure.

La question de l'interprétation est encore plus délicate. Dans la représentation architecturale, qui repose principalement sur les règles de projections, chaque objet du monde réel est représenté par un contour fermé. Le monde s'envisage par ses frontières. La hachure au contraire s'intéresse au dedans et au dehors. Elle nous rend visible la matière qui compose les parois. Elle introduit au sein de la représentation la temporalité du projet en indiquant par exemple les murs à démolir. En matérialisant les ombres, elle nous fait apparaitre la troisième dimension, absente de la projection, et nous révèle la profondeur et la lumière du lieu.

Dans un programme de dessin vectoriel, quelle définition peut-on alors donner à la hachure ? Nous l'avons vu, elle ne peut être réduite au remplissage d'un contour. Mais existe-t-elle alors de manière autonome ou est-elle nécessairement liée aux objets voisins ? La hachure cristallise les différentes questions liées à la codification numérique du dessin d'architecture. Finalement, ce que la hachure nous montre, c'est ce qui n'est pas la géométrie. La hachure ancre la représentation dans le réel. Elle transforme le plan qui se lit en image qui se vit. Finalement ce que nous montre la hachure, c'est l'architecture.

## The Hatching and the Digital Sketch

The hatching is a paradoxical figure. Made of strokes, it reveals a surface. It defines a shape, even in absence of its outline. The hatching has to be interpreted at a second level of reading. What then could be the status of hatching in a digital sketch?

Broadly speaking, two questions arise in a sketch-based system: how to identify hatching in the drawing (segmenting the drawing into graphic entities) and what interpretation should be given to hatching (giving meaning to the drawing).

The issue of identification may seem easy at first: hatching is a set of parallel strokes of the same length, near to one another. However, many other graphical entities meet this definition: a dimension containing several "1s" (111), a dashed line (_ _ _), or the drawing of a staircase, for example. To us, the differences between these objects seem readily apparent, but a recognition system has to retain only the most likely identification. It is always the context, the graphical environment, that will give the status of hatching to a set of strokes.

The question of the interpretation of the sketch is even more delicate. In the parallel projection of the architectural representation, the world is envisaged through its borders. Each object is represented by a closed outline. Hatching, in contrast, focuses on the inside and the outside. It reveals the material composing the walls. By indicating the wall to be demolished in the plan, it introduces the temporality of the project into the heart of its representation. In elevation, it brings the third dimension into two. Materializing the shadows, it gives depth to elements and reveals the light of the place.

In a vector-based program, what definition can we then give of hatching? As we can see, the hatching cannot be reduced to the filling of a contour. But does it exist independently or is it necessarily linked to other objects? Hatching crystallizes the

various issues related to the digital coding of architectural drawing. In fact, hatching does not show us the geometry. It anchors the representation to reality. Hatching transforms the plan that is read into an image, which is lived. In the end, what is revealed by hatching is architecture.

Martin Gayford

# ink Horn

I am about to witness a rare and secret art event. In a few moments, Rebecca Horn's painting machine entitled *Les Amants* will be set in motion. Then, in a matter of seconds, it will execute an enormous abstract image. Already it stands, ready and primed to spurt.

A huge white wall of the Hayward Gallery, fresh and pure, will receive the pigment as it sprays out of the nozzle of the art robot. The end product will be one of the principle exhibits in a large exhibition of Horn's work, *Bodylandscapes*, which opens at the Hayward next week.

Normally, Horn likes to set it off in private, but on this occasion she is prepared to make an exception. So I am standing, well out of range of the gizmo, with a small knot of Hayward staff and creators, waiting for the act of creation to begin. The business end of the device is a tiny spray on a rod that is designed to swivel in complicated ways. At one side there are two large funnels filled with pink champagne and very black ink.

"If you combine black ink and pink champagne," Horn explains, "the result is entirely black, because the blackness of the ink is so much stronger. I named it *Les Amants*, the lovers, to suggest this uneven tension." So there is irony, and a hint of emotional pain, built into the conception of this bizarre machine, as well as absurdity and beauty. The art automaton is also a love machine.

Finally, she gives the signal to begin. Her assistant presses the button. At once, the rod and nozzle start a spasm of jerking, up and down, and from side to side. First a trickle, then great dark plumes of ink shoot over the wall. "It's completely different each time," she says. "The length and height of the space vary, so you adjust it to the differing proportions. If the space is very confined, its range is shorter."

In less than a minute, it is all over. The cybernetic Jackson Pollock is executed, the wall of the gallery dripping and glistening with wet pigment.

The artist is delighted. "Look," she says. "It's like black feathers! And over here

it's like rain, black rain." Further along the wall, the lines are very fine and curved—"like needles," she exclaims. "It's very hard to make a line like that with your hand."[14]

Wei Jia—translation by Sarah McNaughton

# Ideogram

"水墨"是新词, 指的是从传统绘画发展过来的中国水墨画, 这里要谈的"水墨"不是谈材料, 媒介, 要谈的是其观念, 这个观念贯穿于所有中国传统艺术之中, 如书法, 诗词, 音乐, 庭园, 戏剧和舞台等, 包括禅宗, 都是暗示的艺术。

在最具代表性的中国山水画中, 用笔用墨是表现眼睛看到的和认识到的真实, 留白, 即未画的地方是给与的想象, 暗示着天空与湖水, 烟云瀑布, 山石树木的受光面等等。画在一张白纸上的小船暗示着周围空白处无边的天空与湖水, 当你把船拿走或涂掉, 暗示立即消失, 恢复纸原本的样子。(当我第一次靠近Richard Serra的作品感到如此的惊奇与熟悉。)

一个好的欣赏者是同时欣赏形与留白的, 这是观看与想象的过程。一个好艺术家是在白纸上用形象改变空白空间和它的意义, 他可以用笔下竹子的动态使空白成为阳光, 成为雨, 成为雪和风, 这是画家作画与想象的过程。所以画家与观众是十分明确的互动作用。了解这个互动, 你不但可以欣赏传统的"水墨", 还能欣赏其它中国传统艺术。

"Ink" is a new word, one that points to the Chinese ink painting that has developed out of traditional Chinese painting. The "ink" that I am talking about here is neither a material nor a medium; what I am discussing is its concept, and this concept can be found throughout all types of traditional Chinese art, such as calligraphy, poetry, music, gardening, theater, and dance, as these are all subtle forms of art and draw upon Chan Buddhist precepts.

In the most representative Chinese landscape paintings, using a brush and ink expresses the reality that the eye sees and recognizes. The negative spaces and the places that have not yet been painted are areas for the imagination, hinting at expanses of sky and lake, clouds and waterfalls, mountains and trees side by side. A small boat drawn on a piece of white paper suggests that the surrounding blank area might be a boundless sky or lake. When you take away or cross out the little boat, this suggestion immediately disappears with it, and the original appearance of the paper is restored (the first time I saw Richard Serra's work, I had this same feeling of both surprise and familiarity).

A good art appreciator appreciates both what is and what is not pictured. This is a process of looking and imagining. A good artist uses the image on white paper

to change both the blank space and its significance. He can use the dynamics of the brush's bamboo to change the blank space into sunlight, rain, snow, and wind. This is a painter's working and imagining process. Therefore, there is a clear interaction between the artist and his audience. If you understand this interaction, you can appreciate not only traditional "ink," but other forms of traditional Chinese art as well.

Pavitra Jayaraman

# India Ink (INDELIBLE)

In June, every voter in Cambodia's Commune Council election carried a bit of India on his finger. The indelible ink that marked voters' index fingers was made in Karnataka at Mysore Paints and Varnish Ltd. (MPVL). The sole manufacturer of voting ink in the country, this factory, built amid 16 acres of wooded area, with around 100 employees, continues to reinvent itself every few years.

The Mysore factory, like many establishments from pre-independence times set up by the then royal family of Mysore, is a combination of new and old. Two structures were built at the time of the inauguration in 1937, and buildings were added as the company grew. Located in a quiet corner of Mysore city, 1 kilometer after you get off the Bangalore-Mysore highway, every Mysorean seems to know where it is. Ask for MPVL. "The lac factory?" they correct you.

"Many buildings in Mysore have great historical relevance. The palace, public buildings, parks and factories, there is so much," says Vinay Parameswarappa, who conducts Royal Mysore Walks across the city. While many of them are relics, MPVL continues to be relevant today.

MPVL was set up when the maharaja of Mysore, Krishnaraja Wodeyar IV, decided to make use of the wax from the forests that surrounded Mysore. With an initial investment of Rs 1.03 crore, he set up the Mysore Lac Factory. "The maharaja decided to make use of the produce to make sealing wax on a large scale," says M.V. Hemanth Kumar, managing director, MPVL. Sealing wax, which has been used in postal offices across the country and still continues to secure ballot boxes, was the first product of the factory. "In fact, every evening after the factory shuts down, the guard seals the lock with this very wax," says Kumar.

By 1947 the company that was handed over to the government of Karnataka had started manufacturing paint. It was renamed Mysore Lac and Paints Ltd. and was converted into a public sector unit. Wodeyar IV's rule from 1902-40 had been a pros-

perous one for Mysore district, which saw the growth of industry, art, and agriculture. It was under his rule that the Karnataka Soaps and Detergents Ltd. (KSDL), famous for its Mysore Sandal soaps, and Karnataka Silk Industries Corp. (KSIC), which makes Mysore silk saris, were established along with several other industries. In 1989, the lac and paint company expanded further. It started making varnish and was renamed yet again, this time to Mysore Paints and Varnish Ltd., a name it retains today.

But though it was being repeatedly reinvented, its most significant leap took place in 1962 when the organization was chosen to manufacture indelible ink created by the National Physical Laboratory (NPL), Delhi. The ink cannot be erased or washed away and takes about 20 days to fade.

MPVL was now an integral part of Indian democracy.

The process of manufacturing the ink is a closely guarded secret and is based on a chemical formula devised by the NPL, with whom the patent of the product also rests. "We still keep the secret safe and still are the sole suppliers of indelible ink to the entire nation," says Kumar.

The ink was used for the first time in the Lok Sabha election in 1962 and has since been used in every parliamentary election and almost every assembly and local election.

In the 2004 Lok Sabha election, the Election Commission of India ordered 1.67 million 5-milliliter bottles of ink. "At the time, they just placed a dot on the index finger of every voter," says C. Harakumar, general manager at MPVL. In the 2009 election, the requirement went up to 1.9 million bottles, with each bottle containing double the quantity, 10 milliliters.

Each bottle can mark 700 fingers. As the largest state, Uttar Pradesh receives the maximum quantity while the smallest amount goes to Port Blair in the Andaman and Nicobar Islands. In 1978, the company was asked to export its poster product to Singapore. MPVL now exports indelible ink to more than 25 countries.[15]

## Dean Motter

# Inker

Ink. To those of us who toil in the comic book mills, ink is a symbol of permanence. Whether it is the CMYK that brings our work to four-color life, or the India ink we carefully apply to our penciled drawings. Ink is to us what stone, steel, and glass are to the architect. Ink is our posterity.

However, we rarely romanticize ink the way that builders do materials. Ink, you see, is also a verb to us. And as such, one that has created an artisan unique to our trade, the Inker. On the most basic level, the inking of a penciled drawing or cartoon is an obvious necessity of the printing process. And, in the early days of comics and commercial illustration, most artists approached the inking of their work as a somewhat tedious part of their craft.

When the modern comic book came into existence in 1935 with *Big Fun*, the volume of art required on a monthly basis made it necessary to adopt an assembly-line method of producing it, and lo, the "inker" as a craftsman, separate from the illustrator, was born. At first, most were artists' assistants. Inking was a superficial, redundant phase of illustration and was largely regarded as somewhat of a chore. One easily assigned to an underling, or trainee. The inker needed discipline, a modicum of talent, and the ability to re-render someone else's artwork without complaint.

It wasn't long, however, before the craftsmanship of the inker emerged as being able to imbue a work with qualities that could be subtle, visceral, even sublime. These qualities can easily be seen in the funny pages of the day, whether in Alex Raymond's luscious brushwork on *Flash Gordon*, Hal Foster's painstaking quillwork on *Prince Valiant*, or Milton Caniff's expressionistic rendering of *Terry and the Pirates*. While these examples were of the pencil artist's own hand (or that of his assistant), they displayed the qualities that comic book inkers quickly began to emulate.

As the number of comic book titles increased, the artist's pencil drawings tended to become less and less finished, and the inker's role as a stylistic interpreter took on greater importance. A good inker could do what was then considered a booming trade if he was fast, stylish, and reliable. A good penciller knew what to ask for. As the industry grew, the inker's art became more refined. By the mid-forties, certain inkers' own styles become recognizable. They were in demand. Editors and artists often chose an inker, not only on the basis of availability, but popularity and appropriateness to the story.

Even so, inkers remained largely anonymous until the sixties: the Marvel Age. Marvel Comics began running credits for the stories on the "splash page" of any given issue or story. The writer, pencil artist, inker, even the letterer and colorist were listed, often with some jocular nickname, to create the impression of a tightly knit crew (thus was born Darlin' Dick Ayers, Jazzy John Romita, and the ubiquitous Smilin' Stan Lee). The letters-to-the-editor pages soon featured debates by sharp-eyed readers over which inker looked better on Jack "King" Kirby—Valiant Vince Coletta or Jumpin' Joe Sinnott.

Prior to that, one might see the artist's distinctive signature on the title page (e.g., *Batman*'s Bob Kane, *Superman*'s Siegel and Shuster), but even that was more the exception than the rule. Publishers were reluctant to diminish their ownership of their properties with anything that might be considered a claim of any kind. "*Batman* by Bob Kane" was quite often actually done by Dick Sprang and other uncred-

ited talent. It wasn't long before competing publishers, eager to emulate Marvel's growing popularity, followed suit. Eventually, the practice of crediting an issue's artistic lineup became the established convention for the industry. Today, the key talent is usually given a prominent position on the cover of most comics.

In the decades that followed, the once ephemeral art form itself has become more sophisticated and nuanced. Inking styles have continued to become more informed. More accomplished. What was once considered drudgery at worst, and a coveted backstage role at best, has become a vital and recognized part of any comic book's marquee. Advances in printing and desktop graphics technology have made comic book art more varied and adventurous than ever. A good part of the current industry standards have to do with these advances. The talents of onetime unheralded inkers are now gloriously on display.

So it is that we can now romanticize ink as a medium the way architects can romanticize exotic stone, miraculous composite materials, new finishes. We can appreciate the language and the brush—be it as meticulous as Al Williamson or as hewn as Alex Toth. We can admire the calligraphic impressionism or the deliberateness of a Victorian steel engraving in the works of Berni Wrightson and Michael Kaluta. We can experience the Munch-like expressionism in Bill Sienkiewicz's finishes and the Goya-like line of Dave McKean. More than that, today we can properly regard comic book art as architecture. The pencil work is the girder and rebar steel frame; the ink is the concrete, brick, and glass of our building on the page. And each panel is a window onto a moment or a world.

Each story is a city.

Ila Berman

# Invisible Ink

Invisible ink. Perhaps initially thought to be less common to architecture, the medium of secret writing and signifier of the surreptitious is deeply embedded in the histories of covert operations common to espionage and military intelligence as well as a spectrum of political, legal, and monetary agencies dependent on hidden codes and inscriptions intended to ensure either secrecy or authenticity. From the milk of the Tithymallus plant used by the Greeks and Romans to the secret chemical formulas generated by the East German Stasi for use during the Cold War, the range of organic and chemical substances used for invisible writing is both varied and

vast. All forms of organic acids such as lemon and onion juice, wine, and vinegar; bodily fluids such as urine, semen, and saliva; along with a range of chemicals such as iron and copper sulfate and cobalt chloride have been exploited as invisible inks, each employed to change the physical micro-properties of the surface of inscription through material processes imperceptible to the human eye. Encryption is enabled as the fibers of paper are structurally transformed by their interaction with the "ink," producing undetectable material differentials hidden within the surface of the paper that changes its response to heat, light, moisture, or chemical agents such as iodine and ammonia, each of which can be used (depending on the substance of the ink) to develop and therefore expose what was seemingly concealed within the surface's micro-material composition. With organic inks, for example, these differentials might be manifest as two distinct responses to temperature, where the lowering of the burn threshold for the territory covered by the trace is revealed chromatically as the substance dehydrates or oxidizes when heat is applied to its surface.

This dependence of communication techniques on chemistry foregrounds their relationship to matter rather than the structure of signification, revealing not only the criticality of the material trace in terms of substance rather than form but also the importance of the medium that acts as its support—a ground whose distinctive properties and specific material composition are necessary constituents in the coding and decoding of information. In a time when architecture has been overtly (although somewhat surreptitiously) governed by the indexes of matter—the multitude of hidden diagrams following everything from the invisible traces of atmospheric movements to traffic flows—and the effects that these indexes have on the material substrates of architecture, the applicability of "invisible ink" as a concept to describe the secret diagrammatic writing of architects seems entirely appropriate. Although not considered to be in the realm of espionage (except perhaps for those who battle over architectural territories), architecture's inked diagrammatic codes remain entirely concealed below the architectures they generate, and remain invisible to all but their authors or the designated few who are equipped with the analytical processes or methodological reagents to expose or reveal them.

The doubling of the trace as it oscillates between concealment and exposure exploits the liminal territories at the edges of optical perception, as well as the dependence of invisible inscription on transformative agents, processes, or technological devices that enable the expansion of these territories. The duplicity of material indexes operating within different contexts is of course not only limited to espionage as it is commonly used in multiple forms of information exchange and security from the hidden watermarks, holograms, and microprinting embedded within paper monetary currency—its hidden ciphers of authenticity—to the invisible inks used to inscribe confirmation codes on voter registration cards and the invisible barcodes used for the automatic routing of mail. These doubled imprints are dependent on different forms of optical engagement embedded within a single

surface while pointing to the overlay of functions evident in a world governed as much by technology as biology. As our cyborgian relationship to invisible ink is exponentially increased, it may be found to adequately describe not only the microscopic scales at which information is currently etched onto our hard drives, as the methods through which digital codes are invisibly imprinted onto the surface of architectural components to define the ways that these will become routed to building sites and assembled in fabrication and construction.

Ink, the dominant medium through which architects had at one time inscribed their spatial descriptions of a virtual world, has now of course attained a new level of invisibility, its absence all the more evident as the relationship between pixels and interactive digital screens have replaced both the fluid medium and the material surface that once acted as its support. Our current invisible inks are not only the generative diagrams concealed below the architectures that we produce but also the invisible forms of writing—encrypted codes; algorithmic scripts and metadata; hidden ones and zeros, and electronic bits, pulses, and signals—upon which these architectures depend. These invisible media transmit information with energy more than chemistry, involving hidden imperceptible micro-processes whose scales, speeds, and micro-matters all but elude us. Just as we had built a Cartesian world out of the ink that had demarcated the boundaries, edges, and axes of an orthogonal three-dimensional architecture, its displacement by the pixelated surfaces, aggregated molecular bodies, or gaseous atmospheres of our current architectures continuously remind us of the invisible inks that produced them, whereby the medium has, in fact, once again become the message.

Mark Wigley

# inkJet

In architecture schools, we're dealing with the first post-ink generation. Of course there's a lot of ink in architecture, but it's hidden. Ink is inside a cartridge, and the cartridge is put inside a printer, and the moment that the ink makes contact with the paper is absolutely concealed. This is very similar to a general fear of liquids, usually a sexual fear. There's a phobia in architecture that [says] we should not see the release of the ink to the paper. Then ink appears not to be ink. The ink forms an image. Even if one has a sophisticated knowledge of which inks and which kinds of paper give the best image, it's read as an image, not as ink.

In architecture, ink is of course identified with the line—not just the mark, but the line. That means precision, clarification, specification, control, giving instructions. And it cannot be just any ink. Le Corbusier did not win the League of Nations competition because he used printer's ink rather than China ink, but the rules of the competition stipulated China ink.

His being fired from that competition led to the formation of CIAM—there was a decision made that they needed an international union of architects to control, to regulate the flow of commissions in architecture, and the flow of ideas. You can literally say that the mafia of modern architecture is premised on ink. You can further argue that the formation of the architectural profession is directly related to China ink. In the United States, for example, the profession started around 1830, and China ink was required—the crucial thing about it as distinct from printing ink or writing ink being carbon. It comes from soot in a stick. So there's a very particular quality to making the line in carbon.

This black line—this super-black line—is usually done on tracing paper or vellum. The line is floating in space. And it's in the space between ideas and the physical world: a set of instructions that float in a hypothetical space of instruction, somewhere between the brain and the body, between ideas and the work. For this reason, to design something is a mental act, not a physical one. The power of the line in architecture is that it is a very, very precise definition of both idea and of the world, and it's reversible. You can make a drawing of the world, and in so doing catch an idea. Or you can have an idea and project it through the drawing onto the world.

This "ink" exhibition[16] explores the opposite logic: ink as a deep, dark pool, as a place of mystery. It is interested in the dip into the ink, and the stroke—these two gestures. Of course, the Rorschach is the exact opposite of the line. Not just because it's not a line, but because it's meant to be filled. The Rorschach allows you to see what your brain cannot see. So it's exactly not the drawing of the line.

The great thing about all ink, but China ink in particular, is that it's completely filled with different materials: the monolithic effect of ink is produced by animal, vegetable, and mineral materials in different combinations. The illusion of an infinitely monolithic material—which would allow any idea to be registered—is actually made possible by an alchemical mix of organic and inorganic materials. In that sense, ink is filled with secrets. So it makes sense that you allow the mysterious nature of ink to be the main event.

Ink always carries imminent catastrophe. Your shirt covered with ink. The page covered with ink. Your drawing destroyed at the last second by a mistake. So this whole logic that you treat as a kind of scientific research of the blot, of the leak, of the sphere, and of the stain—this is also a trauma. This is like the disaster that ink always carries with it.

A big part of the discourse of ink is to hold it at the threshold, at the point of absolute disaster, to release it under control, and in so doing demonstrate your

superiority over the world of liquids. One could even say that the heroic figure of the architect—controlling the world by controlling the line—is really nothing more than controlling the ink.

This research returns us to this release of the ink and all the secrets the ink spilled out. But instead of telling us that you made a mess, or that we made a stain, you're saying the opposite. You're making very precise research.

Craig "KR" Costello

# Krink

To tell the story of Krink, the world's quickest growing art supply line, you need to hear the story of KR: a terrible art student, a semi-successful vandal, and an entrepreneur who learned everything the hard way.

KR grew up in Queens, New York, in the eighties surrounded by graffiti writers, skaters, punks, and B-boys. Graf was a part of the attitude as much as it was the landscape. Everything was very DIY: steal paint, illegal spots, make markers, emphasize your style, experiment with multiple tools and methods. A lot of it was also based in economy (or lack thereof): sharing and stealing were simply a necessary part of the creative process.

In the late eighties, graf on trains died and the art spilled out onto the streets and highways. With NYC train graffiti, the pieces themselves moved around the city. When graffiti on trains ended, it was the writers who had to move from place to place. Writers became more mobile and so styles and tools changed accordingly. Writers saw the city as an endless canvas to paint on, but as the city cracked down on them, the methods of work and quality of work was greatly affected. Homemade markers that had been the norm were too messy to carry, and homemade inks faded in the sun. Pilot-brand silver paint markers became the tool of the trade yet in many ways couldn't meet this new generation of artists' very specific needs.

In the early nineties KR moved to San Francisco. The scene he found there was thriving, yet different. Most writing took place in parking lots and specified spots. He arrived with a whole different attitude regarding materials and styles. Ignoring designated areas, he used the streets of SF as his very own research and development lab, experimenting with a lot of different tools and techniques to create bigger, drippy marker tags. He also began making his own inks, allowing him to get up bigger, bolder and, now armed with an endless supply of ink, much, much more.

The city changed from block to block, and each building had its own personality and place. Some buildings got painted over immediately, some not for decades, some were in very busy places, while others were in quiet places where no one would see any of the paintings except for other writers. High visibility and ease of execution were ideal.

Access to materials played a significant role: What did you have available? Do you need a ladder? Do you have to climb? Maybe the artist was limited to five cans of paint because that's all they had at the time, or access had been granted because of construction on an adjacent building, or they found a ladder that stacked well onto a Dumpster and it just worked perfectly that night. There were so many variables. KR, a good street writer, had a very keen eye for environment and became very knowledgeable about what materials worked best in an outdoor environment.

KR's experience helped to inform his ink. How should this work? What was wrong then; let's fix it now. This was good for one thing, but tweak it and it was more versatile, etc. From these trials and errors, KR's ink, or Krink, was created. He shared his concoction with a few friends and soon its silver markings dominated the city.

In 1998 KR returned to New York and brought Krink back with him. Before long, its signature style was covering the streets of New York as well. This was around the same time writers began realizing they didn't need to trade in their lifestyle in order to make a living. The Alife store had just opened and was quickly becoming a mecca for street art. They told KR that if he would bottle and sell Krink, people would buy it and they offered to help: it was more of a creative project than a business plan, something to work on collaboratively. It sold and people liked it and it just kept growing from there.

Krink itself is informed by many of KR's experiences and discovering what works, but also it should be noted, it's much easier to make tools for the individual than it is for the masses. So KR had a lot of obstacles and kept working on Krink until he found solutions to create products that look nice, ship well, and work well—It wasn't easy.

Fast-forward to today, and Krink products are shipping daily from a headquarters in Brooklyn, New York, to everywhere from California to Moscow to Bangkok. Krink is part of a global creative community and remains responsive to feedback from that community of professional artists and designers, to kids writing in the streets. Krink makes products that a growing community understands intuitively. In KR's words, "If we make a can of paint that sprays 12 feet high, they understand what that is and where it applies. Everything is constantly evolving into new things and ideas; we are very much a culture product that is growing from new ideas about what creativity is and how to make it."

The product line has grown to offer a number of different markers and inks that are unique to the market in their style, history and quality. And when the collaboration feels right, Krink continues to create limited-edition products with like-minded companies like Nike, Incase, and Kidrobot. The trademark paint drip aesthetic has found its way into art and design, becoming a standard for street-inspired artists on a global level.

It's been 15 years and what started as a product created to fit the specific needs of graffiti writers has grown into a product line with a range of creative tools for creative thinkers.

## Martin Bridgeman and Richard Evan Schwartz

# Line

Geometry starts with a point, a single, indivisible entity. Euclid's *Elements* begins with the definition, "A point is that which has no part."

From points come lines. Euclid's first postulate states that a straight line can be drawn through any two points. Euclid's two-point description of a line is the basis of computer drawing. Even the most complicated drawing can be coded as a finite list of pairs of endpoints.

As lines have infinitely many points, this leap from point to line carries you all the way to the infinite.

The points of a line are barely knowable. True, you can draw a line from two points, but most of the points passed over by your pen are ineffable. In the hierarchy of infinities, the number of points on the line is greater than the number of finite descriptions which can be made in any language, so most points of the line have no description at all. The line is saturated by points which are inaccessible to language. If your pen stops at a random place along your line, there is almost certainly no name for its location.

The line frames the infinite and unknowable, but in itself is knowable.

Diana Martinez

# Mark

*… ink, on your, beauty, diacritical, question, check, skid, tick*
*this day, my words, hit the, on the, make a …*

There are as many definitions for the word *mark* as there are idioms that include it. Its etymology is wandering, complex, and at times mysterious. By most accounts, however, the English word *mark* comes from the word *mörk*, the old Norse word for forest. This seems, at first, a curious origin for the word, unless we consider that the forest—as an objectifiable fact—could only appear as such from its exterior, the point at which one could perceive difference.

Having come from the word for forest—that shadowy environment from which humanity did not yet distinguish itself, the word not only suggests the drawn limit of the forest's darkness but also murkiness itself (*mörk* in modern Swedish as *murk* in modern English means "dark, somber, dusky, dingy, or obscure"). Thus, the word *mark*, itself forms a sort of paradox, denoting both an expansive infinity without perceivable end and the perceivable limit of that expanse.

The limit itself became an object, a line denoting a hard and intentional boundary—the frontier of human settlement. It is no coincidence that one of the many definitions of the word *mark* is "frontier" (as in *march*); a borderland ruled over by a marquess or marquis. The rulers of this borderland protected identity and identified enmity. That precarious space, a place that was neither here nor there was under pressure from either side and could not survive. The marquis's territory would eventually collapse into the no-place of the border, an unoccupiable line.

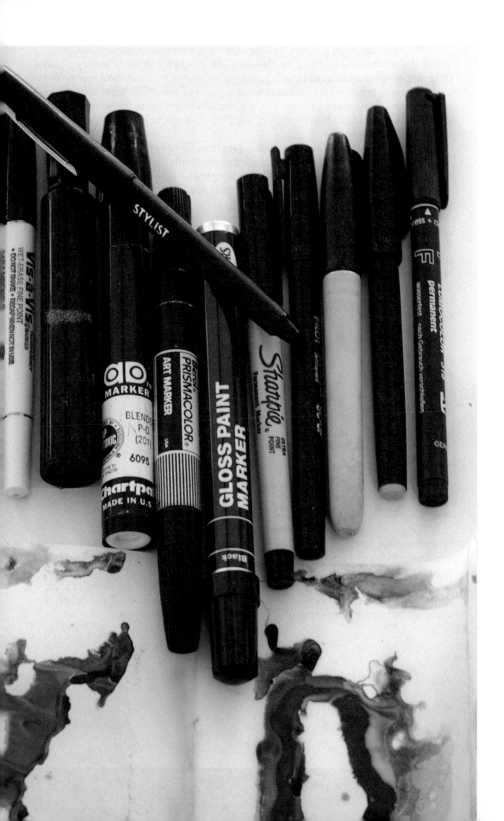

If it was through a seemingly progressive process of objectification by which the mark collapsed into the thinnest line, it was by virtue of mastery that the mark shed yet another dimension, eventually coming to describe a point—the infinitesimally small, in fact dimensionless, point of the marksman. Having understood the forest from without, the marksman sought again to demonstrate a mastery over darkness from within it, piercing through its obscuring veils with precise and lethal vectors.

Perhaps it is only by accident that in Japan marks have long been made out of a sort of distillation of the forest, considering the best-quality ink to be an admixture of pine soot, preserving perfume, and deer horn glue—an extraction yielded from the marksman's prey. In the deft hand of the calligrapher, the forest is transformed into a mark refined.

The mark is nothing more than, nor anything less than, the destruction of blankness. One marks to show that one has been there, to claim territory, to find one's way back home, to hold a place in a book, to remember an important passage. It is a drawn utterance—an irreducible unit. It is only one degree removed from the hand or body but existing separate from it. Utterances do not and cannot exist in written language; wedged between accident and intention, it is a happening transformed by a moment of recognition that remains a record of that very moment.

Nashid Nabian

# Siyah Mashgh

*When the Black Matter meets the erotic, nothingness stands on a pedestal!* Islamist sociocultural logic of operation tries to deny the existence of the female body; as it is considered the manifestation of the erotic, its presentation and representation falls within the forbidden realm. Menstruating women are not permitted to enter a mosque, unless they are only passing through. Even the female corpse is barely accepted and tolerated in sacred architectures and places of worship.

The body of the woman is but one in the long list of things obliterated from the space of the sacred. According to the Islamist laws, representation of the living, whether beast or human, is also forbidden for the fear of idolization of the figure, which is in direct violation of the idea of a unique god prayed to by the Muslim. Hence, a genre of ornamentation is completely absent in the realization of Islamic sacred space. Figurative representation instead gives way to scripture, and to geometrical and organic patterns; the real enters the realm of abstraction in order to leak into the space of the sacred. In this context, calligraphy acquires architectural agency, as scripture and its associated concepts become the main genre of sacred ornamentation.

Although calligraphy is common in many cultures, in Islamic countries, it is one of the few manifestations of the sublime to survive religious censorship. The Persian word for calligraphy, *khoshnevisy*, is a combination of the word for exquisiteness, *khosh*, and *nevisy*, scripture. Hence, as a creative act, calligraphy goes beyond simply writing text to touch the realm of creating beauty and capturing visual experience through the act of writing. Yet, since Iranian/Islamic calligraphy is executed according to very specific rules in which each one of the characters is largely unchanging, one might find it absurd to consider this a creative act. But in *khoshnevisy*, the sublime is manifested through perfectly implementing curvilinearity in each and every constitutive part of the scripture through repetition. The exquisiteness of a master's work is achieved after years of recursive exercises that consist of writing and rewriting the very same words, or even the same letter. I use the term *recursion* as opposed to *repetition* to describe this training, since in each iteration of the letter on the white canvas, the master is one step closer to arriving at perfection. In Persian, the object created through the act of calligraphy is called *siyah mashgh*, or black scripture.[17] It is as if the ink—the black matter—is itself a part of how the sublime is manifested in the curvature of each and every word, as its different iterations juxtapose each other one after the other, fixating different stages of perfection in time and space.

When the black scripture leaves the white canvas and moves into the place of worship, it becomes the cradle of an ideology documented through scripted words within the sacred space that nurtured that ideology. The cross-pollination of words and mortar creates architectural masterpieces. In the cultural context of pre-Islamic Revolution Iran, the *Vogue* models photographed against the background of the scripted domes of the city of Isfahan's mosques cannot be considered anything but an unthinkable and utterly unwelcome alliance![18]

The unthinkable happens again once the black matter finds its way onto the body of the woman in Shirin Neshat's photographs.[19] The agent of ideological representation inscribes and visually describes the boundary conditions of the very object that is denied the right of presentation or representation within that same ideology. This tautology challenges the very core of the ideology itself.

In Tanavoli's work, black matter once again finds a way off of the white canvas and eases into the third dimension.[20] The word *nothing* is scripted calligraphically, corporeally and quasi-sexually, as a volume. The art and the medium historically responsible for documenting an ideology and an inscription of its sacred literature are both utilized to represent "nothing!" Does this contradictory marriage between the medium of broadcasting meaning and the concept of nothingness hint at the intellectual bankruptcy of the ideology in question?

Sunil Bald

# Nib

Instruments of control bely the precarious state of their authority. Such is the case with the nib, a diminutive word for a device with great responsibility—to direct the flow of a viscous mass into a precise line that can be shaped into the contours that may themselves contain figures, volumes, ideas, or directives. The nib was but the end of the quill, the precisely shaped surface of the hollow calamus that attached the feather to the body of a large bird of flight. A swan, a peacock, a goose, or turkey, in descending order of glamour, the first and largest feather was best, the second and third acceptable. Plucked from flesh, the quill had a violent beginning; when in use, its origin was thereafter reenacted in reverse, the pressure exerted on its nib pushing into the surface of the paper, the pressure of the contact releasing the flow of ink through capillary action onto the sheet. Thus, the nib is a device that demonstrates the power of passive coercion.

When steel nibs appeared at the beginning of the nineteenth century, their shapes duplicated the hand-carved feather tips that preceded them. A parabolic curve, lengthening, coming to a point at each end, and then retreating 180 degrees to form a slit in the tip that resolved itself in a circle, would hold the ink through surface tension as it awaited its release. The nib itself was a manipulation of a surface that could direct a liquid, not through containment but by taking advantage of the physics of fluid dynamics. The nib was dipped, capturing the fluid and holding it in the space of the slit, until the slit was so slightly disturbed through the pressure asserted on the tip by the hand as it pushed into vellum, parchment, or whatever membrane yielded to its point. Each carved nib held its own unique signature, a combination of the feather and the hand of the carver, a signature that was further individuated by the stroke of the user.

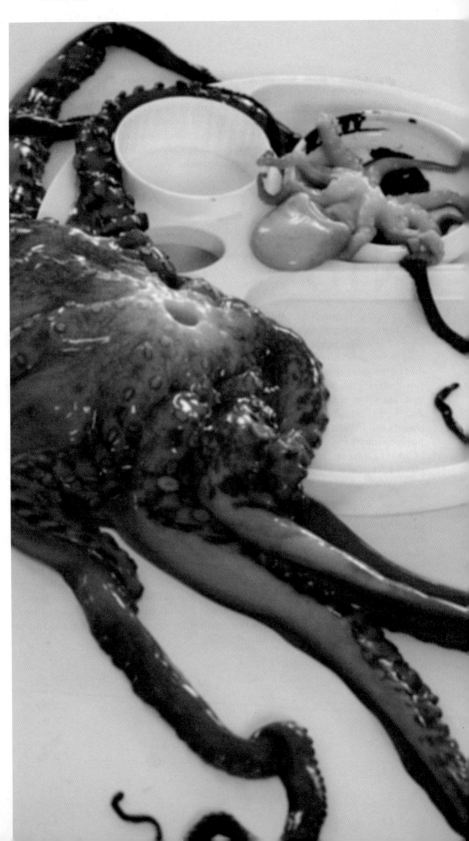

With the ballpoint, ink was contained and mechanistically released in a manner that tamed the ink's mischievous nature and almost eliminated the risk of accident. With the Rapidograph, a disciplined vertical grip minimized the signature of the draughtsperson, giving the authority of objectivity to the orthographic line. And finally, the complete disengagement of the nib and paper accomplished by the inkjet printer is comparable to the disposability of the stick-on tattoo. Each step of the nib's mechanization, and eventual disappearance, removes it from its corporeal beginning, and dissipates the carnal permanence of "putting it down in ink." As Greenaway's reinterpretation of Sei Shonagan's *Pillow Book* acknowledged, when paper blurs into flesh, the nib can control observation, emotion, and sensation, but only until its subject pushes back.

## Martin Ariza Medrano and Javier Navarro Alemany

# Octopus Ink

Estar Más Perdido que un Pulpo en un Garaje

El joven Jack poseía entonces un carácter tan impulsivo que a veces se dejaba arrebatar por él. Era algo ocurría quizás con demasiada frecuencia, aunque nunca antes había llegado a perder el control como en esa ocasión.

—Esto voy a lamentarlo el resto de la vida—se dijo para sí, con el revolver aún humeante en el extremo de uno de sus ocho brazos.

Jack había vaciado el tambor de su arma sin pestañear siquiera. Aunque hay que decir que Jack carecía de pestañas.

El estrépito hizo que los pájaros huyesen despavoridos y que por unos segundos oscurecieran el cielo del jardín en desbandada. Todo ocurrió en una plácida mañana de primeros de junio, mientras Dolly se tostaba junto a la piscina.

Después de contemplar el cadáver de su chica por un tiempo indeterminado, Jack se dirigió en silencio hacia el garaje con ese movimiento sinuoso que dejaba a su paso un rastro de gelatina.

Su brillante piel parecía moteada por el pincel de un inspirado Pollock, aunque él habría cambiado éste útil pellejo de camuflaje por un doble contorno al estilo Warhol, algo que hubiese remarcado mejor su mórbida silueta.

Y ahora la pobre chica volvía a pagar el pato de su obcecado temperamento. Él ya había sido injusto con su novia con anterioridad, aunque esta vez había llegado demasiado lejos.

Dolly era una preciosa actriz venida de otro mundo y todos decían que contaba con una prometedora carrera a corto plazo. De las estrellas vino, y a convertirse en estrella parecía predestinada. Pero ahora los celos infundados del chaval lo habían arruinado todo, cubriendo de balas el futuro de ambos.

Su corta relación había ido a las mil maravillas hasta que ella regresó a casa después de un par de semanas de rodaje en Malibú. Jack descubrió en la espalda desnuda de la chica el rastro rojizo de unas ventosas que no podían ser suyas.

Sólo un mes antes él le había regalado un poema donde le decía lo mucho que la amaba: "Tuyos son mis tres corazones—había escrito sobre una hoja de papel con la tinta de sus entrañas—si no te conociese, si tu nave no hubiese venido a la Tierra creo que yo habría salido a buscarte sin saber bien adónde ir."

Ya en la penumbra del garaje, Jack trasteó en una caja de herramientas sin saber tampoco qué buscaba. Así hasta que se quedó quieto, abrazando una gran llave inglesa fría. Entonces se sintió irremediablemente perdido y fuera de lugar.

—Jack, eres un tonto—escuchó decir a sus espaldas—¿cómo has podido dudar de mí?

Al girarse sobre sus ocho tentáculos voy que Dolly le miraba piadosa desde la puerta. La chica estaba... viva. Él desconocía que para los nativos de Venus una sola muerte no es suficiente, que seis balas disparadas a bocajarro no pueden destruir tanta belleza y armonía. Jack era un completo descerebrado, pero ¿qué puede esperarse de un pulpo con tres corazones?

## Octopuses Have Three Hearts: A Story in Black and White

At that time young Jack had such an impulsive character that at times he would let himself be carried away. It was something that occurred maybe all too often, though he never lost control like this time.

—This will be the lament of the rest of my life—he told himself, with the revolver still smoking at the end of his eight arms.

Jack had emptied the gun's barrel without even batting an eyelash. However, it is known that Jack lacked any eyelashes.

The racket sent the terrified birds flying away, and for a few seconds the garden's sky darkened. It all happened a pleasant early June morning, while Dolly was sunbathing by the pool.

After contemplating his girl's cadaver for some time, Jack went to the garage with a sinuous movement, leaving behind him a gelatinous trace.

His shiny skin seemed dappled by an inspired Pollock brush, though he gladly would've changed his useful camouflage hide for a double contour one à la Warhol.

It would surely have emphasized his delicate silhouette.

Now the poor girl was paying again for the consequences of his stubborn temperament. He had been unfair to her in the past, but this time he had gone too far.

Dolly was a lovely actress from another world, and all agreed she was to have a promising career in the short term. She came from the stars, and to become one she seemed predestined. But now the kid's unfounded jealousy had ruined everything, covering both their future with bullets.

Their short relation had gone wonderfully well till her return home after shooting for a couple of weeks in Malibu. Jack discovered on her back's naked skin a reddish trace from suction cups that couldn't have been his.

One month earlier he had given her a poem in which he'd said how much he loved her "yours are my three hearts"—he wrote it on a piece of paper with ink from his entrails—"if I didn't know you, if your ship hadn't come down to Earth, I believe I would've gone out searching for you without knowing well where to go."

In the garage's dim light, Jack felt around in a toolbox not knowing what he was looking for. He remained still, hugging a large cold monkey wrench. He felt irreparably lost and out of place.

—Jack you are so silly... he heard behind his backs... how could you doubt me?

Turning around on his eight tentacles he saw Dolly kindly looking at him from the doorway. The girl was... alive. He didn't know that for Venus natives only one death was not enough, that six bullets shot point blank cannot destroy so much beauty and harmony. Jack was a complete moron, but what can you expect from an octopus with three hearts?

Michelle Fornabai

# Pareidolia

Pattern recognition, codified in digital processing from the filtering of bitmap images to finding flaws in error detection, is also implicated in the cognitive processing of sensory stimuli and language. Yet seeing patterns in random or meaningless data, or meaningful patterns within situations that appear meaningless to others, may constitute pareidolia, a psychological phenomenon involving a

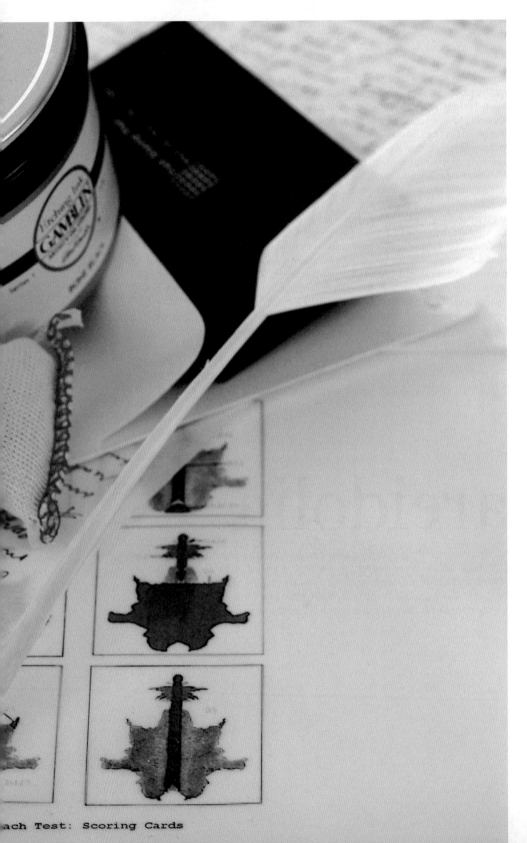

ach Test: Scoring Cards

vague or random stimulus being perceived as significant. Pareidolia, from *para*, which means "beside," "with," "alongside," with *eidolon*, an "image," "form," or "shape," is a subconscious mental reevaluation or configuration of directly observable phenomena. A type of apophenia, pareidolia focuses on the seeing of patterns in specific sensory-based stimuli—turning something that was not present into something that was actually perceived.

Like statistical "false positives" caused by excesses of sensitivity, apophenias constitute a distortion of reality present in both psychotic, autistic, and neurotypical subjects. A "specific experience of an abnormal meaningfulness of coincidental phenomena," evinced in associations between objectively unrelated events, apophenia may be underpinned by a hyper-associative cognitive style, linked to an exaggeration of the normal human tendency to attribute mental states where none are indicated, rather than to dysfunction in the assessment of causality.[21] Distinguishing true pattern or random chance from mere coincidence involves replacing unpredictability with statistical probability.

Coincidence is the noteworthy alignment of two or more events or circumstances without an obvious causal connection. A discordant accord, an "accident," that is "opportune" and "appropriate," in the Chinese term *shi*, "coincidence" connotes more than mere coincidence, carrying the suggestion of "a good match," something that in the colloquial sense "goes with" something else.[22] Distinct from random chance, *shi* finds each throw of a die as being self-caused, the results as also involving the appropriate coincidence of the good or bad luck with which each player was endowed.[23] By ruling out the equiprobability of outcomes between different players ostensibly doing the same thing because they are not the same, "coincidence" blocks the immediate path to probabilistic analysis[24] and complicates causality with the idiosyncrasies of material circumstance.

Positively correlated with heightened awareness, yet negatively susceptible to unfounded inferences, "associative processing" is common to the cognitive phenomena of creative thinking, paranormal belief, and thought disorder. Such associative processing is related to perceptual processing on one hand, and to digital processing by signal detection and noise on the other. While apophenia is considered a key symptom of the early schizophrenic illness and may underlie the vulnerability to paranormal and delusional beliefs, there is an apparent paradox of similarities between thought processes belonging to opposite ends of a continuum of adaptive behavior.[25] Perceptual distortions and cognitive slippages, classified as Incongruous Combinations, Fabulized Combinations, Deviant Responses, Inappropriate Logic, may reflect a higher inclination to give uncommon associations deriving from a lower response criterion in reporting the presence of a signal, identified in several areas of visual but also semantic noise.

Rorschach is a directed pareidolia. In Rorschach testing, the multiple inter-pretations of accidental form determine the relation between normal and abnor-mal, coincidence and cliché. Indeterminate form and ambiguous stimuli posit an inverse relation between information and randomness; the more probable conveys less information. While the normal is determined by statistical probability, poetry emerges through singularity.

Constituted between intention and improvisation, my ink paintings begin by developing coincidental marks through material transpositions and conceptual associations. Working on unstretched, unprimed canvas, paper, or mylar, begin-ning with the soft canvas or blank book, the works use material and perceptual soft-ness to oscillate between figuration and abstraction. The fold constructs figuration through symmetry yet also acts as a hinge or joint; the inkblots provide abstract fields, produced by chance, both as a result of material interaction of two mediums (ink + mylar) and as a result of a gesture or action.

In the production of sensual variations and qualitative differences, the *Ror-schach Series* paintings and the *Projective Drawings* explore sensory perception relative to materiality. In the painting process, figural and associative meanings are anchored determinedly, while other multiple readings are left latent, to be dis-cerned by the viewer.

Babak Bryan

# Plotter

The act of drawing is an act of marking ideas conceived within the mind and making them visible, specifically to be looked at. The true purpose is not so much as a relay of information to others but as a deeply personal act that makes the drawer's inter-nal thoughts clear to themselves. Unlike a dialogue that loses the grip of its content to the haze of memory, the drawing marks a permanent path that can be traced repeatedly to retrieve the original inquiries. By plotting trajectories onto this map, the drawing traces through these seemingly disparate notions and generates a co-hesive understanding of the noise within the brain. The outlined path can be readily followed. This enhanced process makes clear not just the conclusions of ideas, but the entire duration of how it came to be. Consequently, the logical interrogations

can be evaluated and the outcome is better justified. Drawing is not just to see but also to think. Plotting makes this visual thinking possible.

Drawing was once linear and manual. Each thought was individually transcribed into a unique mark on the page. In the plotter, the process becomes automated. Yet the direct relationship between thought and mark is maintained. The process remains linear, though no longer manual. The machine plotter became the tool by which the mark was made, and disseminated. Because of its abilities to reproduce, the plotter inadvertently shifted the focus of drawing from a personal dialogue, to a communication with others. The intimate conversation between the author's mind and eye was extended to include all those that could receive their very own personal print. Tracing through the intent of the plot got murky as the observer got further away from the investigation. While the reach of the plot may have expanded, the depth of the mark became shallow. Ultimately, with the current mode of digital drawing, the mark has become virtually suspended. Instead of being the necessary first stroke, the inked mark is now made last. With merely a simple keystroke made once the interrogation has been concluded, the drawing is plotted at the end. The drawing becomes an afterthought.

Plotting has a parallel definition that is equally important. While still relating to the making of measured drawings that trace thoughts or outline forms, to "plot" also means to scheme or to strategize. It is not just drawing that is the mode of architectural thought; by plotting, we are deliberately conscious of our thoughts toward the achievement of specific outcomes. Recording or tracing the act of drawing not only serves to tell how we got to where we are but also allows us to determine where it is we want to go. In some cases, a plot may be understood to be sinister. In the broader sense, the act is at the least strategically self-serving. As a person, the plotter intends to achieve a predetermined goal. However, as a machine, the ink-plotter seems to have lost this similar intentionality.

Unlike the earlier manual methods, within the digital medium, the image created on the screen is inkless. While it can be said that the representations of these virtual images are comparable to the ones marked with ink, the digital image is now also dynamic. Often this has been expressed as an advantage. The animated screen allows for the excitement of movement to be seen unfolding in real time. Drawing in this sense has become ever more like seeing. Instead of freezing time in a static image, we see movement just as it occurs in reality. However, by continuously reducing the distinction between the visual reality of the seen world and the drawing that investigates how it functions, we lose our ability to be critical. The disembodied virtual drawing is continuously in flux. Since it is constantly able to adapt to its constraints, like a liquid that only holds the form of its container, it is otherwise completely formless. Because of this, the trace of its evolution is left behind. Every

change made to the virtual image is done with an act of erasure. Movement is really cut and paste, erase and redraw. The critical evaluation of movement is superseded, leaving only its representation.

Ultimately, we must question if these assumptions deserve to remain true. Can the criticality of the historical drawing be updated for our current digital practices? Like other tools that get reappropriated for purposes other than for what they were originally intended, can the ink-plotter be repurposed as a digital tool? We maintain our criticality when we are actively engaged in the process of creation and not merely mesmerized by the beauty of the content. How then does plotting fit into this mode of practice? Clearly the architect remains a plotter, constantly scheming for a better design. Ink-plotting is likewise not just a historical practice. To ink a drawing means to affix it permanently, making it rigid in both form and evaluation. The importance of remaining thoughtful and aware in the act of drawing thus requires that drawings become static. By reincorporating the act of ink-plotting into the process of developing a drawing, we can recalibrate not just our methods of making but also of thinking. This will inevitably remake drawing as forethought.

Nader Tehrani

# Poché

Artificial boundaries between disciplines are a commonly held convention, and yet they are overthrown as easily as they are constructed. The separation between architecture, interior design, and decoration serve convenient ends, and yet it is often hard to determine where the domain of one begins and ends—the realm of the interior encroaching on the outside, the outer skin migrating in, and the depth of the wall implicating both. This syndrome is even exacerbated by the ecology of the profession, where scopes of work, by necessity and practicality, need to be defined—separating skin from interior planning and landscape, or core from shell. Theoretically, the nature of the discipline has also made it convenient to develop conceptual categories by which each can readily associate with certain strategies—the exterior being associated with its "object-hood" (the icon, the façade, the figure), and the interior with spatiality (the vault, the womb, the atrium). The realm between the interior and exterior, the poché, has no popular presence

outside of cryptic discourses reserved for architecture. With patronage reinforcing the artificial division of labor between various specializations, it is becoming harder to fabricate an architecture of reciprocity between the interior and exterior.

Historically, the thickness of walls emerges in response to a structural necessity, the absolute requirement of mass for the sustenance of spanning domes—the Pantheon serving a paradigmatic example. What is discovered in this mass, however, is a domain of play, with space carved from the architectural figure to create from this conceptual void a new territory. The creation of this space is as much an architectural invention as it is a feat of real estate gain. The various niches, the structural orders, the play of concavity and convexity all conspire to create an architecture that expands the space of the interior while radicalizing the perceptual and experiential limit of the defined space. The interstices between the interior and exterior are also associated with the liquid mass of concrete that forms the space between the two—a technology that is a unique Roman invention. Importantly, the mass conceals the relationship between the interior and exterior, letting the concrete negotiate the overall geometry of the whole (the circle) with the individuality of its parts (the niches).

In later histories, with the invention of reinforced concrete and steel framing, the discipline is freed from the necessities of mass that it once required for structure. For instance, Le Corbusier's *fenêtre a longuer* or free façade both served to underscore this liberation, whereby the exterior liner is no longer in service of structural necessity. Instead, the modern building confronted the question of mass through constructive skins, separating and overlaying various laminations—for waterproofing, insulation, vapor barrier, and finishes. Without the necessity of mass there was also no longer the necessity of poché, as such. Nonetheless, the nature of architectural discourse is such that it survives simple causality; the conceptual development of the poché had long escaped the linear narrative of structural necessity, and had already been reinforced by other architectural alibis to serve as a basis for light or program—such as is evident in the Villa at Garches, or at Kahn's Unitarian Church, where the thinness of modern construction is veiled by the apparent mass but in service of a range of architectural contingencies.

In current adaptations of the wall, new technologies have once again impacted the nature of the liner between inside and out. Curtain wall construction, rain screen systems, digital fabrication, and smart materials have altered our lens on mass into microscopic inventions at the nano-scale. The construction of depth is a challenge that defies contemporary conventions, with new laminations becoming thinner, smarter, and even more adaptive. Herein lies the potential and architectural instrumentality of the poché, no longer defined by "need" in any simplistic sense but rather to imagine spatial and formal strategies that redefine

the architectural type altogether. If the conventional function of the poché is to buffer the relation between the interior and exterior, our efforts have been to bring these two realms into confrontation: projecting the interior onto the exterior, impressing the outside onto the inside, and developing techniques of "molding" as a vehicle to manifest the contents of the building as an indexical device—as if displaying the inner workings of the building to the outside. Here, the world of the free plan and the world of the load-bearing wall are placed in suspense, if only momentarily, to imagine alterative organizations and systems to calibrate space, representation, and thickness.

Neil Armstrong

# Pocket Protector

I am, and ever will be, a white-socks, pocket-protector, nerdy engineer, born under the second law of thermodynamics, steeped in steam tables, in love with free-body diagrams, transformed by Laplace, and propelled by compressible flow.[26]

Ashley Schafer

# Printer's Ink

In ink's cast of characters, printer's ink assumes the role of superhero; it has been imbued with special powers. Victor Hugo gave license to kill architecture, and yet, paradoxically, print has the ability to generate space.

This space of print extends beyond the metaphoric, i.e., the didactic or discursive space of an architectural journal or book. Of course the "little magazines" identified by Denise Scott-Brown (as well as some extra-large books) can be understood to provide places for disciplinary debates or discourses. Instead here, I am referring to those books and journals that construct a literal, physical space.

While some cut or configure paper to create spaces in-between pages, such as the accordion folds of Edward Ruscha's *Every Building on the Sunset Strip*, others form a space within the page itself. Bruce Mau's canonical *Zone 1/2* uses the density of ink on the page as a spatial embodiment of the contemporary city where he designed "an object that wasn't an illustration of the content, but a model— something that performed and behaved like the city itself." The oversized *Any* magazine produced a contested space between text and image, through a non-hierarchical layering on the page "to establish each page as a site of ideas, where image and text were inseparable manifestations of the same idea." The covers of *Praxis* consistently create literal spaces that embody the editorial position of each issue within the thickness of the ink and paper, which are variously perforated, stamped, thick-coated, laser-cut, multilayered, laminated, embossed.

Beyond design, the very process of printing contains an immanent spatiality. Intaglio, letterpress and offset presses all necessitate the fabrication of a metal plate containing a mirror image of the desired image to be printed in ink on paper, but each holds unique spatial potentials.

Intaglio printing requires the fabrication of a single-use plate, acid-etched to create negative incisions on the surface. Each printed page necessitates the production of a unique plate, a mirror image of the entire printed page as a single object. The ink settles into the voided furrows of its surface, and a high-pressure roller squeezes the paper against and into the grooves, creating a topographic palimpsest of its surface while transferring the ink from plate to paper. The positive, raised image stands in relief from the paper.

Capitalizing on the alphabet's reproducibility and reducibility, letterpress printing (or movable type) reassembles modular letters for each printing. The plate of a movable-type press is built up from an additive set of parts, letters that stand in positive relief from the surface of the plate. The heavy metal press pushes the raised field of individual letters against the surface of the paper, transferring the ink and marking an indentation on the surface, a space in which the ink rests.

Offset printing relies on the creation of a photographically sensitive plate that activates an ink receptive coating. Ink adheres to this coating and is transferred to a rubber blanket, and then to the paper. The paper remains flat, reducing space of print to the thickness of the ink.

Although in some respects visually similar, the content of print transmitted and read via computers, Kindles, iPads, mobile phones, etc., is fundamentally dif-

ferent. As print becomes pixels, the white screen (light-emitting pixels) with black letters (light-blocking pixels) are made legible through not a presence but an absence of light. The space of printing is not simply inverted to become void—which still remains a space defined by its solid—but it is evacuated, flattened into the flickering of electronic 0s and 1s, the most elemental alphabet. What can the darkened pixel, aspatial, ephemeral, and absent, kill?

Kate MccGuire

# Quill

Teri Rueb

# Reed Pen

Reed Pen\
across the page
slithering scratching sliding
I am the letter *r*, rolling and spilling off the point,
searching, finding, forming a phrase.
load the tip, slipping
ink streams out of control
bleeding black overtakes white
pushes back,
the surface scraped
like a landscape
worn through by water, wind, ice.
the force of a geologic gesture
scaled to the stroke of a hand
hovering,
then landing a letter *s*
written with a reed
sprung from the shore
a stalk standing
straight in my mind. rushing
lines fold in on themselves
tumbling across a toothy expanse
racing to the edge,
a fibrous fringe,
driven by the sharp prow
of a pen planting
row after row,
of tangled rivulets.
ink on paper.

Peter Galison

# Rorschach

In a brown cardboard box come ten cards, printed in Bern, Switzerland. Verlag Hans Huber is so concerned about the quality of their reproduction that it will only use the same antique printing presses that stamped out the first edition of the cards in 1921. And it won't print at all if the humidity and temperature do not match the secret instructions that have been passed down over generations. You will be instantly sued for unauthorized duplication of the cards, and psychologists around the world stand vigilant, ready to pounce on wrongful distribution or even casual public display of the images. At the same time this box of plates may well be the most studied object of the last hundred years: several *million* people have not only examined them but recorded the innermost details of what they saw. What are these cards? To answer (or even not to answer) is to present yourself. Just insofar as these cards are described, they describe the describer. Not only do these objects talk back, they immediately double the observer's language with a response that pins the speaker on a psychogrammatic map. These are the cards of the Rorschach test; and they don't mind sending you home, to the clinic, or to prison.[27] [ ... ]

Not only did these cards talk; they did so in virtue of their form and color down to the smallest detail. If the blots suggested even a shard of human design, certain patients would seize on that fragment, losing their own ability to speak from within. For this reason, nothing was more important to Rorschach than creating and reproducing cards that would register as undesigned designs, unpainted paintings: "[I]f the small printed border is not sufficiently precise on some of the blots [after cutting the sheets] or still partly visible here and there after pasting, the blot could still leave visible a small bit of intentionality [*Absichtlichkeit*], and there are [schizophrenics who] react very negatively to the tiniest hit of intentionality."[28] In order for the subject to speak, the card, and the card's author, had to find a perfect silence. This meant that every blot must be produced with exquisite care. Demanding fine adjustments even at galley-proof stage, Rorschach insisted with regard to one card that "the light tones, especially in the upper right, must be darker so that the color looks somewhat flatter."[29] Unintentional arbitrary form would emerge only by the extraordinary exertion of a determined and fully intentional design: an exquisite art of artlessness.[30] [ ... ]

As the Rorschach came to be a diagnostic tool deployed in an ever-expanding number of contexts, its categories were naturalized. In the Second World War, the Americans adopted the test as a standard entry exam for many kinds of service.

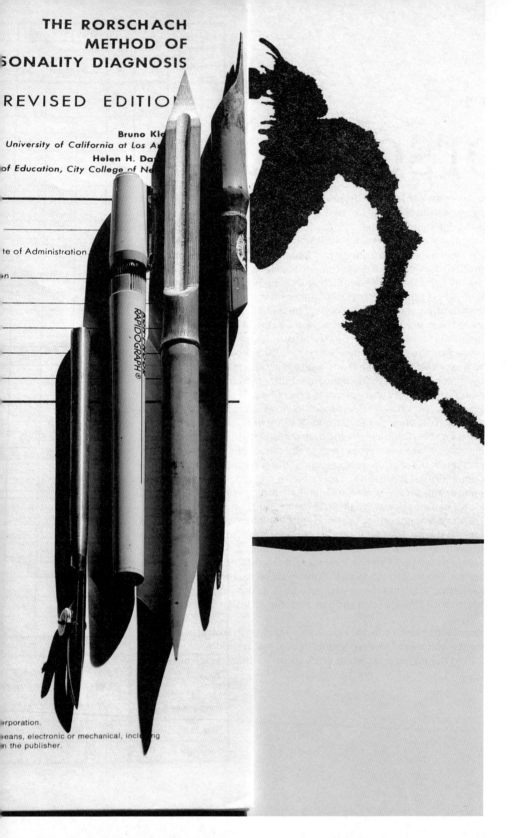

Germans used it to test for racial type in their racial settlement (and annihilation) in the conquered East. When the Nazi war criminals took the test in their holding cells, the tests entered a long debate over the psychology and sociology of evil.[31] More proximately, Rorschach tests have had a long history in assisting counselors in their provision of career advice in schools and companies. And in the courts, the plates continued to figure in forensics, from custody battles to sex crimes. Beyond its practical uses, the inkblot system has become a symbolic technology; the locution "something is a 'Rorschach'" has by now been lodged in the everyday speech of all the European languages. Far more than the widely used thematic apperception test or the word-association test, the Rorschach is truly a *saturating technology*, one that, by its visual omnipresence, meanders through the rhetoric of literature, art, and politics. At that powerful intersection of the literal and the metaphoric, the Rorschach test reinforces our sense that there is a complementary relation between an objective, neutral "test pattern" of the original inkblot and the subjective distortion of that pattern by our internal patterns of perception. We have learned—in no small measure through this specific technology—to envision the self alternately as a filtered camera and as a powerful projector.

Of course, the Rorschach test did not rotate the self from aggregate to apperceptive all by itself. The late-nineteenth-century history of "inner life" is a vast subject, one that includes cultural and social changes across many domains; this was a period in which new forms of domestic architectural space, family dynamics, autobiographical narratives, mass media, and political culture all took hold. But within this broader shift, the Rorschach test has played a dual role: it both reflected this new interiority and, more actively, provided a powerful assessment procedure, a universally recognized visual sign, and a compelling central metaphor.[32]

Alexis H. Cohen

# Ruling Pen

George Adams junior (1750–1795), author and mathematical instrument maker, describes a ruling pen, also known as a drawing pen, in *Geometrical and Graphical Essays* (1791):

> it consists of two blades with steel points fixed to a handle, the blades
> are so bent that the ends of the steel points meet, and yet leave a sufficient

> cavity for the ink; the blades may be opened more or less by a screw, and being properly set, will draw a line of any assigned thickness…a small quantity only of ink should be put at one time into the drawing pen, and this should be placed in the cavity between the blades by a common pen, or the feeder…[33]

The ruling pen, typically used in tandem with a ruler, produces stable and predictable lines of ink, a defining characteristic often contrasted with the quill pen's more flexible but unreliable ink-flow. The ruling pen's ability to make consistent lines of even the finest weight made it a valuable tool in the practice of technical drawing, a type of drawing that emerged in the sixteenth century to represent the measurements generated by developing fields such as astronomy, navigation, military engineering, and land-surveying.[34] In the eighteenth and nineteenth centuries, ruling pens were standard items in drawing kits, which included compasses, protractors, rulers, and other instruments that facilitated precision drawing.[35]

Without the guidance of a well-trained and patient hand, the ruling pen and ruler do not guarantee the production of precisely inked lines. In *Drawing Instruments 1580–1980*, Maya Hambly calls attention to the demands the instrument places on its user: "[b]efore commencing work on an ink drawing, dozens of trial lines have to be drawn before the desired line thickness is achieved and then the pen has to be repeatedly refilled by means of a dropper or filler from a pot of waterproof Indian ink."[36] The metal blades of the ruling pen also require "regular cleaning, using either a penknife or a razor-blade or fine emery paper to remove the dried ink."[37]

Mabel O. Wilson

# Sepia

"When I see them now they are not sepia, still, losing their edges to the light of a future afternoon. Caught midway between was and must be. For me they are real," writes novelist Toni Morrison in her magnum opus *Jazz*. By imagining the cache of old photographs as "not sepia," Morrison's character suspends the decay of the image. Colored by deep brown, red undertones, with hints of gray, the photographs in Morrison's world mark time by referencing places elsewhere and elsewhen—drawing them into the polyrhythmic cadence of life in Harlem in the

1920s. Sepia's watery muted appearance in Morrison's prose ignites a circuit of retrospection for her protagonist and readers that propels the past into the current moment and beyond toward the future. *Jazz*'s structure, the unfolding of events through narrative, deploys its namesake genre's characteristic call and response. Jazz music stretches its temporal elasticity—its rhythms accelerating and braking according to the improvisational play between musicians. In page after page of lyrical passages, Morrison churns her prose until it becomes a brew of multitudinous temporalities.

For more than a century and a half, photographic processes have captured time that in today's high-speed digital cameras can be calibrated down to milliseconds. For Walter Benjamin, the photograph destroyed the auratic singularity of the bourgeois object of art. Its technical precision and mass-production techniques signified the apotheosis of modernity. The mechanical reproduction of art would be a revolutionary art form, Benjamin pronounced, one that would "emancipate the work of art from its parasitical dependence on ritual." However, as archival photographs from the nineteenth and twentieth centuries reveal, the pressures of time could not be exiled. Even though they were mass-produced, photographs nonetheless retained their uniqueness as owners imbued them with unique commemorative value.

That exposure to light, chemical reactions, and moisture could yellow and fade the photograph, was known by early photographers who in response invented methods that halted the degradation. For example, sepia dye when mixed with emulsions of bromides and metallic silver reduced the deterioration of the image. The brownish-black dye served as a tool of preservation that retarded the chemical reactions producing the contours of the photographic image. While sepia dye actually slowed the effects of decay, its reddish brown hue became a signifier of time passing, of pastness. Through sepia dye mixed with other chemicals the world could be graphed onto a whisper-thin sheet of pressed pulp.

The use of sepia dye did not start with its incorporation into nineteenth-century photographic processes, but its use began much earlier during the empires of Egypt and Rome. The practice of extracting sepia dye from the sacs of cuttlefish was first done for the purpose of making ink to be used for drawing and writing. To remember something beyond the present moment necessitated the scribing of lines to form figures, hieroglyphs, and letters. Sequences of ink marks and washes were used to recount events and record ideas—these formations marked the passage of time. We can read of the past through lines that dance across papyrus and parchment. Drawing as movement in time enacts remembrance—caught as Morrison reminds us "between was and must be."

Xu Bing—translation by Jesse Robert Coffino

# Shuimo

"水墨"两字在中国据有多层含义, 材料、画重、书卷气等等, 似乎是无限的。中国的水墨画一幅幅安静的垂挂下来, 或者手卷式地徐徐展开, 世间竟然有这么好看的东。水和墨与宣纸接触后所出现的是奇迹, 每一笔都是绝无仅有的。由画家之手让水与棉纤维相遇的时刻, 在水被空气带走前的瞬间内, 物质的性格在缝隙之间的 "协调" 或 "斗争" 之痕被 "定格"。这是下笔的经验、预感力与 "自然" 互为的结果, 它在可控与不可控之间。这奇 "迹" 将感动每一个求天人合一、习性温和的中国人: 美感由生。中国的大画家齐白石是戏墨的专家, 是调控水与棉物矛盾的高手。同样是宣纸, 他的画却能调动出更多棉质的美感。

　　在中国对艺术的评价其实都是对艺术家人的评价, 一个人的、境界、品味、修养, 也就是总体质量, 是通过 "水墨" 之痕迹体现出来的。我们还以齐白石为例: 我们看他的 "蔬果册" 里的那幅 "白菜辣椒图" 上, 两只红的不能再红的尖椒, 什么人能把这辣椒看的这么红, 只有那种对生活热爱至深、天真、善意的眼睛才能看到的。我们从中看到中国水墨的魅力; 墨色衬托出辣椒的 "红", 也看到白石老人艺术的秘密: 他为什么可以是在艺术史上少见的, 越老画的越好的人? 因为, 他越到晚年对生活越依恋, 他舍不得离开。对任何一件身边之物; 任何一个小生灵都是那么惜爱。万物皆有灵, 他与它们莫逆相交了一辈子。他们之间是平等的, 一切都是那么值得尊重, 那么美好。他晚年的画, 既有像是第一次看到红色辣椒的感觉, 又有像是最后再看一眼的不舍之情。爱之热烈是恨不得能把一切都看在眼里带走的。这是超越笔墨技法的, 是 "笔墨等于零"

(注) 还是不等于零范畴之外的。

(注) 中国80年代艺术界曾有过一场对于 "笔" 意义问题的争论。

The two characters in "*shuimo*,"[38] taken together, have many levels of meaning in China: material, painting type, scholarly style, and so on. The implications are practically limitless. A Chinese *shuimo* painting hanging quietly, panel by panel, or as a hand-scroll, gently unrolled—a thing of such beauty does indeed exist in this world. In the contact between *shui* (water), *mo* (ink), and Xuan paper,[39] with each inimitable stroke, an unusual mark emerges. When, by the artist's hand, the water encounters the fiber, in the instant before air carries that water away, in the crevices, in the marks made amid "mediation" or "struggle," the character of the material is "fixed." A combined result of experience with the brush, intuition, and "nature," it lies between the controllable and the uncontrollable. And this unusual "mark" will move any Chinese person with a mild sensibility who seeks unity with nature. From this, beauty is born. Renowned Chinese painter Qi Baishi, an expert at ink play, was also a master of controlling the contradiction between water and fiber. And so with Xuan paper his paintings could incite a greater range of beauty from the fibers.

In China, the appraisal of an artwork is actually a personal appraisal of the artist: the individual; his state of mind, taste, cultivation; and his overall quality. They

are all manifest in the traces of *shuimo*. To continue with Qi Baishi, in *Cabbage and Pepper Painting*, a leaf from his *Fruit and Vegetable Album*, we see two chili peppers so red that they couldn't possibly get redder. What kind of person sees peppers so red? Only eyes with a deep love for life, innocent and sincere. We also see the allure of Chinese *shuimo*—the contrast of the black ink brings out the "red" of the peppers—and we see the secret of the aged Baishi's art. Why, after all, is he the rare instance in the history of art of someone who painted better the older he got? Because the older he became, the more attached he was to life, the more unwilling he was to leave. Anything he found at his side, any tiny creature, was cherished so deeply. Each and every thing has its own spirit, and he engaged in a lifetime of intimate fellowship with them. They were his equals. Everything merited such respect and held such beauty. The paintings of his later years possess both the sense of seeing red peppers for the first time and the reluctant feeling of seeing them for the last. The ardor of this love was the urgency of taking everything you see along with you. This transcends the technique of brush and ink; it lies outside the scope of whether "brush and ink equal zero"[40] or do not equal zero.[41]

Karel Klein

# Smudge

A smudge can't exist without an other. Something needs to be smudged. My photograph, my window, my knife blade, my face, my clothing, and of course, my drawing can be smudged. I suppose a smudge can be smudged. But would I notice? What's the difference between two smudges? Is a smudge a form? Can a smudge have a figure? If I see a face in the smudge, is it really there? If I deliberately shape a smudge, is it still a smudge?

I think I made a mistake when I smudged my drawing. But sometimes I hear about people intentionally smudging. Before Game 7, Phil Jackson smudged the air of a locker room with burning sage to help players into game faces. I've seen artists in galleries making smudge drawings. When I put on makeup, it often ends with a smudge. My children do nothing but smudge.

Things of nature can also smudge. My dog can smudge my drawing. The rain can smudge my drawing. A rock can fall on my drawing. But would I call the mark left by the rock a smudge? I think I heard of an artist who makes drawings from tree branches marking a page while the branches move in the wind. I suppose the same tree can smudge its drawing after it's done. But would its drawing ever be finished? If it's never

finished, when would the smudging begin? Nature can smudge. Is a cloud a smudge? Turner rendered clouds by smudging paint. The sky makes clouds by smudging water. What's the difference? If I see a face in the cloud above me, what's different from seeing a face in the painting of the cloud in front of me? Richter smudged paintings to sense the sublime. If I sense the sublime in the smudges of nature, am I sensing something different from Richter's painting?

Murmurations of starlings look like smudges. At moments, the smudges look like something. When I stare at the coffee grounds after I'm done with my espresso, I see the murmurations of starlings. It's tempting to study tasseography so that I might understand these smudges better. But is there anything to understand? Rorschach was so convinced that these smudges revealed secrets that he formulated a system of smudges. But the secrets were in the looker, not in the smudges. Or so the story goes.

Leonardo suggested starting with a smudge to compose a battle scene. Careful composition would look too static, too stable. The horse with the twisted neck, kicking away terrified from the violence was born in a smudge. Is *born* the right word? Leonardo saw a horse in the smudge. Rorschach would rather say, "The horse was in his head, not in the smudge. The smudge merely opened the door." But it's more interesting to believe the horse was in the smudge, and Leonardo opened the door to what was in the smudge.

Is all that I see out there nothing but random keys to open the infinite doors to my head? Or is all that I see nothing but infinite doors to open? When I smudged my drawing yesterday, did I make a mistake? I tried not to smudge my drawing. I'm not sure why.

Heather Rowe

# Spill

Ink can be both the container and its contents. Ink is formless and form.

Sometimes, standing in line at the grocery store, I imagine what it would be like to faint—which way I would fall, back of hand to the forehead for dramatic effect, my body falls to the floor. I then awake to see my surroundings from that perspective.

Spilling down stairs—the first time I wore high heels I found myself gently sliding down the bottom half of a large staircase and landing very elegantly in a reclining position.

Abrupt spills—walking down the sidewalk in Manhattan I looked down to find both my feet caught within a ring of plastic strapping. This ring tightened and

in a split second I was lying horizontal on the sidewalk. I was wearing a long black coat so I imagined to a distant passerby I might be a thick, inky line stretched across the pavement. Amazingly, only a parking attendant caught this slapstick act, as the street was deserted at noon that day.

Buster Keaton makes spills seem effortless.[42] He quickly recovers from them with ease. "Keaton acquired the nickname "Buster" at about 18 months of age. Keaton told interviewer Fletcher Markle that Harry Houdini happened to be present one day when the young Keaton took a tumble down a long flight of stairs without injury. After the infant sat up and shook off his experience, Houdini remarked, "That was a real buster!" According to Keaton, in those days, the word *buster* was used to refer to a spill or a fall that had the potential to produce injury."[43]

When the body takes a spill, it is usually contained. The crash might cause some destruction to the surrounding architecture, but it is limited. A liquid spill can be far-reaching. It has no structure and forms to the surroundings.[44]

An ink spill can trigger a traumatic memory.

A red ink spill can spread like blood.

An ink spill can induce a state of terror.

An ink spill might never be erased completely from a white silk blouse, no matter how vigorously and violently one attempts to wash it away.[45]

An ink spill can ruin someone else's traditional line drawing of an Italian church.

An ink spill can try to erase the past in order to make way for the future.

An ink spill can connect one with the past, when they were 23 years old.

An ink spill can be deliberate.

Or it can be an accident.

It can be ambivalent.

The spiller might be aggressive and want to start a fight.

The spiller might be idle and careless with more than just ink.[46]

Karen Finley

# Stain

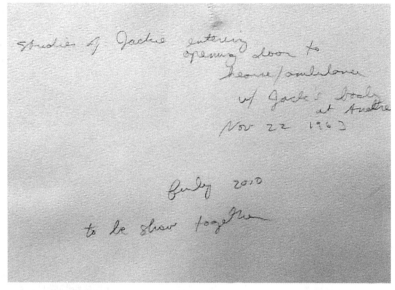

Pamela Sams

# Stamp (SEAL)

Not the glazed sponge, engraved stamp, or moist agreement,
nor the warm dull soft picture forced tight against the escaping light,
nor the marked approval adhered to the decision press
squeezed together making an airless secret,
nor a permanent vow cut off and glued,
Because, look, none of this fits on the shelf for occasional use.
Officially, this is not just me.

In 1897, the Architectural Registration Act of Illinois made Illinois the first U.S. state to require architects to be professionally licensed. This act, modeled under the state's existing regulatory systems for medicine and law, stated that any graduate of an approved four-year curriculum in architecture could sit for the exam and if they passed, they would be able to have a professional license from the state of Illinois and would be required to sign and seal drawings and specifications created by them or under their direction.

I wonder why architecture does not have a symbol that is associated with it. The practice of law has a scale to indicate the balancing of justice and truth, and medicine is symbolized by the caduceus; both symbols have their origins in Greek mythology.

I have been a licensed architect in the District of Columbia for a decade, and I am a project architect at a global architecture firm that has 24 offices in the U.S., Europe, the Middle East, and Asia. Although I was entitled to order a seal with my registration number on it once I'd passed my Architectural Registration Exam and became a licensed architect, I never have. Currently at our firm, like many large firms, the project architect (PA) doesn't seal the drawings; the drawings are signed and sealed by the partners in the firm or a project manager (PM). I think the rationale behind this is that although project architects are the technical lead and the main person responsible for coordination across the different disciplines, they do not have the final decision in allocating resources to the job. This decision is ultimately the responsibility of the PM, who must negotiate the schedule, scope, and fees for the project. In a firm that does work in every state, it would require a large number of licenses to keep current if the PAs had to get and maintain reciprocity in all of the states in which they have a built project.

There are many people who are a part of the architecture team and sometimes, there is more than one licensed architect working on the drawings, but only one person signs and seals the whole set. What would it be like if each sheet had the signature and seal of each licensed architect that worked on it and the signature of all the team members? It would really look like a contract document.

I have created thousands of drawings and documented hundreds of thousands of square feet in built space, but I have never sealed and signed a drawing with my personal licensing number or signature. Recently, there has been a policy change, and the PAs will be required to sign and seal their own drawings. I think this is a positive change that will elevate the role of the PA and have her feel more invested in the documents thereby improving their quality.

We don't seal all the drawings we deliver to the client. In general, we have several submissions during the course of the schematic design, design development, and construction development phases. All these submittals will require a combination of drawing sheets, reports, and eventually specifications. The design team including all consultants who submit specifications and reports will seal and sign their bid set. This is the final construction document set, and our seals represent an official acknowledgement that these documents are technically sound and sufficient to give guidance to the construction team.

In many European countries, a professional licensing exam is not a necessary step to becoming a licensed architect, one only has to graduate from an accredited architecture program and satisfy the prescribed apprenticeship for two or three years. The requirement of the exam in the U.S. distances the profession from the academic training. Does it indicate a distrust of the adequacy of the college training on the part of the profession?

I think that in smaller firms or firms that work in a more localized region, they would still have the senior architect who is responsible for the technical and coordination efforts sign and seal the drawings. The significance of the seal is to show that the state's licensing board has checked that the architect has fulfilled the licensing requirements, i.e., education, experience, and professional examination. The signature is to indicate that the actual licensed individual is the one using the seal. All of this is to protect the public's health, safety, and welfare.

I don't ever remember seeing a sealed drawing by a famous architect in exhibitions of their works, at lectures or in monographs. Recent searches for sealed drawings by Ludwig Mies Van Der Rohe, Frank Lloyd Wright, and Eero Saarinen weren't successful; construction drawings for built works showed a title block with the architect's name printed but no seal or signature. The title blocks don't even have a space for the seal.

Marc Tsurumaki

# Stipple

I. While line is the privileged terrain of technical pen and drafting ink, the practice of stippling allows for the introduction of qualities and effects typically excluded by precise linearity. Composed of individual dots or specks of ink arrayed in varying patterns of aggregation, density, and scale, stippling shifts the logic of the *rapidograph* from that of *disegno* to that of *colorito*—from terms of outline and profile to those of shade and shadow, mass and volume, texture and contour. Paradoxically, this shift in effects to terms associated with other more atmospheric representational modes (such as painting or rendering) is in fact based on the very precision of the medium itself. Modern technical pens possess the ideal qualities for stippling by hand. The precision of the steel nib guarantees a reliable replicability in the size of the dot as well as a consistent flow of ink that allows for the efficient production of the large fields of inky flecks necessary to build up an image through a density of marks. The simulation of perceptual indeterminacy—the blurring of defined edges into diffuse tones and gradations that characterize the stippled image—is the result of the exactness of the technique.

II. The invention of stippling in intaglio, ascribed to the Italian engraver Giulio Campagnola in the early 1500s, allowed for a more subtle and variable reproduction of tone than the preexisting techniques of hatching and cross-hatching and without the potential graphic confusion of a proliferation of lines. What would seem a mere technical refinement—a resultant of the constraints of mechanical printing, which requires the image to be reduced to a pure binary of black-and-white—arguably points to a profound and lasting shift in the way that images are produced and reproduced, disseminated and understood. While operating within the requirements of the engraved plate, stippling creates the capacity to atomize the complexity of an image, any image, into a constituent field of self-identical elements. The nature of the mark is exactly limited, either black or white, present or absent, on or off—while only the differential intensities of the field create the coherence of the final image.

III. Stippling creates an oscillation between collective effect (the image produced) and individual constituent element (the dot of ink) brought into relation through the technique of the draftsman. Unlike the pixelation of the computer screen or the gap between frames of cinematic film, which operate below the threshold of legibility, the

marks of the stippled drawing remain visible even as they cohere into a recognizable totality. In fact, much of the pleasure of stippling derives from the perceivable presence of this very fluctuation—whereby the overall form dissolves under close optical inspection into a field of individual marks of varying density. The simultaneous perception of the represented content and its existence as a gradient field of marks generates a double reading—a coupling of simulation with its exposure as artifice. Stippling generates an illusion continually in the process of revealing itself—producing a perpetual shift between the evidence of the technique (virtuosity) and its invisibility.

Caroline A. Jones

# Stroke

Paint participated in the topos of the studio and helped establish its distinction from the workshop; the terms of this painterly discourse were also carried over to postwar America from Romantic sources in nineteenth-century Europe. The virtuoso handling of a viscous paint that leaves traces of its maker's hand (in Rembrandt's or Delacroix's works and in modern readings of Michelangelo) is a signal not of sweat but of genius. It is the style of the gifted individual who might rise above the anxious need for a certifying artisanal professionalism, beyond the dogged labor required to "finish" the piece. The painterly form that surfaces its lack of finish conveys in its very sketchiness its status as a mere approximation of the divine internal design, or, alternatively, serves as testamentary evidence of the hurried, spontaneous inspiration of its artist-creator. The ideology of the spontaneous brushstroke, as we might call it, was codified in nineteenth-century France, primarily in opposition to academic notions of *fini*. Whenever public opinion or politics turned against Romantic artists, "finish" was prized again as a sign of honest labor and professional skill: "The *fini* became the guarantee for the bourgeois, and especially for the great bourgeois known as the state, against being swindled...The *fini*...symbolizes careful work and is a pledge of social responsibility."[47] But defenders of Romantic artists, such as musicologist Charles Rosen and art historian Henri Zerner who are quoted above, have their own anxieties which must be defused—the work of *fini* must be faulted (in their own moral terms) as less honest than the rougher painterly style. Ideology is seen in the deployment of finish; its operation is carefully shielded from recognition in *malerisch* art: "But if the academic *fini* is work, it is shameful work. It cleans up, rubs out the traces of the real work, erases the evidence of the brush strokes, glosses over the rough edges of the forms, fills in the broken lines, hides the fact that the picture is a real object made out of paint."[48] Finally, the battle is won in gendered terms familiar to us all.

Painterly work is man's work, honest and crude; the other is Other. Citing Baudelaire and Thomas Eakins, Rosen and Zerner emphasize "the domestic metaphor" that undergirds (shall we say "lifts and supports"?) "the symbolic meaning of the *fini*." Finish is conflated with polish (furniture polish as much as social poise) in Rosen and Zerner's text, and with "lady's work," in Eakins's borrowed words.[49] Never mind that their own desire, like Baudelaire's and Eakins's, is to undercut the opposition by a comparison that is not necessarily true so much as telling. The feminization of labor has its own history, but it is perhaps no accident that this history accelerates in the early industrial period that witnessed the rise of Romanticism, and was borrowed again in the anxious gender negotiations following the Second World War.

Thus the manly, athletic work encoded in the spontaneous brushstroke is not housework; nor, in some sense, is it "labor"—that category of human effort required for survival or wage. It is gratuitous, expressive, personal; it is as playful and as serious as sex, as productive as God's act of creation. The modern studio, as site of this quintessentially individual act, is functionally upper class, and male. The ideology of the spontaneous brushstroke is one of freedom—it is made in response to the inner needs, or the aesthetic desires, of its independent creator... The spontaneous brushstroke (or the sensual fingerful of clay on the sculpture) has no boss, no patron, no mouths to feed. The studio as a space for unencumbered individualism is figured in that freely applied paint; the sensuality and generosity of excess pigment conveys broader freedoms that are very appealing, even if they are circumscribed by the narrow boundaries of an individual taste. We are invited by the artist to identify with that freedom, to be constructed as that individual, in viewing his art. In that case, the more heroic the better, we say.

The continuity of this ideological identification between the brushstroke, the individual, and the studio is compelling, a strong thread picked up time and time again in the developing rhetoric of modern art. In trying to define "the liberating quality of abstract art" for a group of art professionals in 1957,[50] Meyer Schapiro (like Delacroix, like Rosen and Zerner) located this heroic individualism in the paint itself. As the following quotation from Schapiro makes clear, the painterly brushstroke symbolized the individual in opposition to "ordinary...work": "Hence the great importance of the mark, the stroke, the brush, the drip, the quality of the substance of the paint itself, and the surface of the canvas as a texture and field of operation—all signs of the artist's active presence. .... *All these qualities of painting may be regarded as a means of affirming the individual in opposition to the contrary qualities of the ordinary experience of working and doing.*" (Emphasis added.)[51] Artists themselves were sympathetic to the conjunction of paint and individualism (and later, depoliticization). By 1951, the pairing was an article of faith; in Robert Motherwell's words, "it is only by giving oneself up completely to the painting medium that one finds oneself and one's own style...such is the experience of the School of New York."[52] Giving oneself up and finding oneself: dismantling and reconstructing the individual through the painting and viewing dynamic—these themes weave through the discourse, always implicating the studio as the privileged site of origin

for the solitary creative process. Philip Guston conveys this in a wonderful image he credits to John Cage (master of Silence), depicting the studio not as always empty, but as always emptying: "When you start working, everybody is in your studio—the past, your friends, enemies, the art world, and above all, your own ideas—all are there. But as you continue painting, they start leaving, one by one, and you are left completely alone. Then, if you're lucky, even you leave."[53] Imaginatively leaving one's own studio is perhaps analogous to annihilating one's past—eradicating conscious individuality in order to reconstruct it in the painting at hand. The painting then becomes the only presence in the studio.[54]

## Akira Yamasaki, Takeshi Iizuka, and Eiji Osawa

# ink Stick (SUMI)

Fullerenes[55] in Chinese Ink Sticks ("Sumi")

Abstract: Small amounts (up to 0.1 percent) of $C_{60}$ and $C_{70}$ have been detected by high-pressure liquid chromatographic (HPLC) analysis of toluene extracts from soots used to manufacture Chinese ink sticks, or Sumi. These soots have been prepared by slow burning of pine wood, and later various seed oils. Turpentine oil, the major constituent of pine wood oil, has been found to produce twice as much fullerenes as does toluene when used as the combustion material. The yields of fullerene from unsaturated combustion materials decrease with the iodine number, reaching zero in the saturated compounds. Possible role of fullerenes as the effective gloss enhancer for black color is suggested in reference to the known technique of adding a natural red pigment to Sumi practiced in Japan.[56]

## Adolf Loos

# Tattoo

People with tattoos not in prison are either latent criminals or degenerate aristocrats. The urge to decorate one's face and anything else within reach is the origin of

the fine arts. It is the childish babble of painting. But all art is erotic. A person of our times who gives way to the urge to daub the walls with erotic symbols is a criminal or a degenerate. What is natural in the Papuan or the child is a sign of degeneracy in a modern adult. I made the following discovery, which I passed on to the world: the evolution of culture is synonymous with the removal of ornamentation from objects of everyday use. I thought by doing so I would bring joy to the world: it has not thanked me for it.[57]

Taeg Nishimoto

# Technical Pen

Before you pick it up, you must do some breathing exercise. The kind that you breathe in and out slowly staring in one direction so your sightline does not stray off. This is important because without it your sense of control of the movement of its tip does not equate with the control of your body.

After a moment of exercise, you then pick it up and shake it gently with your palm, feeling the movement of the ink inside. It is at this point that the flow of ink and your blood circulation become aligned. Not unlike when you realize that you are bleeding at your fingertip because you poked it with something and you did not realize it happened, your gaze is fixed on the way the ink streams out from the invisible hole at the tip.

There is an undisputable sense of trust in this operation between the flow of ink and your consciousness. When your blood is circulating well in your body and the ink is smoothly streaming out, the sense of union with a touch of invincibleness is undeniable. You feel you can sail to an unknown continent; now you are navigating on the vast whiteness of the paper. The rich and constant flow of ink instantly becomes the newly discovered chart. In no time, you begin to feel that you can make no mistake in this journey. What's more, in this operation everything gets recorded so the idea of making a mistake only evokes the sense of security. Like sailing, raising and lowering it create two simultaneous sensations of time; one of the immediate situation and the other of a longer, projected future that is eventually to come.

Here and there, you hold your breath as if to make sure that your blood is circulating normally. Not very often but it happens that a drop of ink spontaneously and mysteriously oozes out from the tip while you are holding it up. It looks and feels like a bloody nose, and yet you know there is nothing wrong with your blood circulation. In this complacent relationship, you can imagine the catastrophe it causes when the flow of ink stops. It is worse than running out of gas on the road because there is no warning from the dashboard. When it happens your instinct is, like an injured animal in a trap, to lick the tip with your tongue. This may do the magic and you continue. Or you realize that it actually ran out of ink and add more into the tube, or you have no idea and decide that ink may have dried in the tip and needs washing. Washing the tip requires a surgeon's precision, holding it under the running water of the faucet. Staring at the running water seems to crucially determine the continuity of your journey and the wellness of your blood circulation. And when you finally feel the slight movement inside the tip, it is as if you have just rescued a failing heart of someone you love by C P R.

At that point, you breathe normally again with your steady blood circulation and the flow of ink, to continue the journey.

David Benjamin

# Thermo-chromic Ink

Ink on the page, smart and reassuring, sets some small piece of the world in its place. Ink orders complexity. Ink transforms a blank surface into a concept, to be interpreted by one or many, once or repeatedly, as long as the page exists.

But what if ink changed over time? What if ink morphed before our eyes when we touched it or breathed on it? What if ink depended on the perceiver as well as the creator?

Might ink then show us not only the information in a careful mark, but also the information in a physical environment, at the very moment the ink is being viewed?

Might ink as a medium be dynamic and reciprocal? And how might we pause—truly pause, and imagine new possibilities—if the ink of our drawings blinked awake from the page and conversed?

## Michael Young

# Tone

On the plane playing field of optical representation there are two terms that constantly cross paths with often competing desires. As far back as we care to throw the aesthetic discourse surrounding representation we find this distinction and inherent struggle. The terms we use for these two aspects are *line* and *tone*. These two terms have an even higher degree of friction if we place them in the medium of ink. When ruled by a pen, ink provides the sharpest, cleanest, precise line. When loosed by a brush, ink washes provide the most evenly continuous saturated gradations of tone.

Let us briefly give both sides a backstory. A line collapses the page toward a precise definition of boundary, of outline, of shape. It is organizational thought on paper, thus the often commented upon congruency between design and drawing in the Italian word of *disegno*. For architectural representation, a line draws in geometry and its regulatory metrics. As this trajectory is taken toward the extreme limit, a line becomes immaterial, nonexistent in that which it represents, pure quantitative demarcation. Tone, on the other hand, is always fluctuating and variable. Tone consists of both value and hue. Value is the gradient of dark to light, black to white. Hue is the gradient of warm to cool, the temperature of the tone. Tone is qualitative in its variations, provoking sensory responses in an observer, and often creating the illusion of depth through shade and shadow. Subtle gradients of ink wash model bodies to become fully fleshed out; tone tones musculature. As tone moves closer and closer to the painterly it begins to devour lines and dissolve figural contours into the ground of atmosphere. While resisting an easy slide into musical analogies, it does make sense to describe tone as tuned. It is variable along a gradient, manipulated between two constraints set above and below as maximum and minimum values. It is common to find texts that speak of tone in percentages of pure black and describe the techniques for tonal modifications as those of subtle adjustments that slightly raise or lower tonal values in relation to their perceivable contextual constraints.

Designers that deal with digital platforms are familiar with the distinction between raster and vector images. The image that has gone through a rasterizing process has entered the realm of pixel control. Each pixel has a value and a hue that describes its data visually. The clustered collection approximates the image to a level of resolution. The image that is vector-defined treats visualization as a simulation of computation. The line is not "fixed" to the visual pixels but manipulated through calculations and then resimulated as a new length, a new position, a new orientation, etc. The linear definition is computationally based, but the visualization is pixel-based. It is easy to see the comparisons between vector as line and raster as tone. The interesting collision that happens in digital representation is that all visual information at some level is processed and judged based on tonal attributes. As architects working through digital design processes, we are constantly manipulating vector information while we are visually judging raster information. In other words, we are manipulating lines and judging tones. And once our representations pass into a fully rasterized format, all we have is tone. This begins to imply that a historical position from which to understand parametric variation is bound up with the techniques for judging and manipulating tonal gradients. It can always be a little more, or a little less. Always. Without a conceptual and aesthetic position from which to understand gradient variation, parameters will be defined solely by the economies of pragmatism. The study of tonal manipulation can provocatively ground, or with ink, provocatively grind us into reevaluations of our digital transmissions.

Amy Carpenter

# Tortoise Shell

When I was in the eighth grade, my grandfather ran over a tortoise in our backyard with a lawnmower.

At first he thought it was a rock and got frustrated (to mask his worry about possibly having to replace the blade), but then he quickly saw the ooze and realized that it was "just a tortoise."

He kept on mowing.

I felt horrible, sick as I looked at the bits of shell sticking through the grass, the gloss, and goo spewing around as though it had been an egg that could walk but was now shattered next to my bare feet.

Had I known that the tortoise's shell was one of the first methods of moving thoughts silently between people, I would have looked for more code in its fragments.

As it was, I stared at them for quite a long time, almost until my grandfather passed by me again.

His was a very big yard, and I was just visiting.

I don't think for one second that he meant to hit the tortoise, to kill it, I really don't.

And yet.

We'd been fighting. I wanted to go live at my aunt's house.

I'd been going on about it for weeks and he wouldn't budge.

Later that same night, as I was falling asleep, on the brink of dreaming everything and remembering nothing at all, the tortoise's broken little body appeared in my mind. Its beige dots and brown squares. The squares inside squares and the furrowed shifting in its curved shell that pulled one outlined room into another.

The shattered symmetry hovered as a magnetic haze, collecting my thoughts and organizing them gently: my grandfather, his home, the rooms we were sleeping in, him lying in his bed, me in mine, two little dots all alone but together, intact, protected. So many other rooms empty, all his children gone, some dead, some far away, my aunt never calling. Just me, him, and these rooms.

Life was us living together. In these boxes, intact.

Untouched in spite of so much violence, so much loss.

Leaving would shatter even that.

I drifted asleep feeling lighter, freer, as though a curse had been lifted from me. A hate removed, a storm gone.

The next morning I woke feeling solid, complete, whole. Certain. Knowing.

I'd decided to stay and even my body understood this.

Over bowls of hot oatmeal and small mugs of coffee, I told my grandfather and he looked at me for the first time in weeks. Expressions can carry a lot that words never do, and from that moment on everything changed and got better.

Carl Andre

# Typewriter Ribbon

Carl Andre, "now now," typewriting and ink on paper, 8¼ × 8 inches, 1967.
Art © Carl Andre/Licensed by VAGA, New York, N.Y.

SOME,

LONE -

FEEL

FO

GOING

YOU'RE

Sean A. Day

# "u" (SYNESTHESIA)

| "u" (grapheme) | | "u" (phoneme) | |
|---|---|---|---|
| 2% | black | 0% | pink |
| 2% | red | 0% | orange |
| 5% | white | 4% | black |
| 5% | pink | 4% | red |
| 6% | magenta | 4% | white |
| 6% | orange | 9% | brown |
| 7% | green | 11% | gray |
| 8% | blue | 11% | yellow |
| 18% | gray | 13% | magenta |
| 19% | brown | 20% | green |
| 22% | yellow | 24% | blue |

[Trends in Synesthetically Colored Graphemes and Phonemes[58]]

Marcus Vitruvius Pollio

# Vermilion

For example, which of the ancients can be found to have used vermilion otherwise than sparingly, like a drug?[59]

I will now return to the preparation of vermilion. When the lumps of ore are dry, they are crushed in iron mortars, and repeatedly washed and heated until the impurities are gone, and the colors come. When the cinnabar has given up its quicksilver, and thus lost the natural virtues that it previously had, it becomes soft in quality and its powers are feeble.

Hence, though it keeps its color perfectly when applied in the polished stucco finish of closed apartments, yet in open apartments, such as peristyles or exedrae

or other places of the sort, where the bright rays of the sun and moon can penetrate, it is spoiled by contact with them, loses the strength of its color, and turns black. Among many others, the secretary Faberius, who wished to have his house on the Aventine finished in elegant style, applied vermilion to all the walls of the peristyle; but after thirty days they turned to an ugly and mottled color. He therefore made a contract to have other colors applied instead of vermilion.

But anybody who is more particular, and who wants a polished finish of vermilion that will keep its proper color, should, after the wall has been polished and is dry, apply with a brush Pontic wax melted over a fire and mixed with a little oil; then after this he should bring the wax to a sweat by warming it and the wall at close quarters with charcoal enclosed in an iron vessel; and finally he should smooth it all off by rubbing it down with a wax candle and clean linen cloths, just as naked marble statues are treated.

This process is termed γάνωσις in Greek. The protecting coat of Pontic wax prevents the light of the moon and the rays of the sun from licking up and drawing the color out of such polished finishing.[60]

Catherine Veikos

# Vermilion

Vermilion: n. the color of life; the most brilliant, toxic and fugitive red; the blood of dragons and elephants (Pliny); orange-red pigment derived from the precious ore of mercury, cinnabar (HgS) mined predominantly in China, India, and Spain; alchemically produced synthetic successor to cinnabar, created through various recipes of sublimation, the first recorded in eighth-century China: mercury and sulfur were heated in a flask until vaporized, then the black, recondensed crystalline mixture was painstakingly ground until it developed into an increasingly brighter and finer red color. In *Il libro dell'arte* (1437) the fifteenth-century painter Cennino Cennini counsels that such recipes are many, especially among friars, but that painters should not waste their time with such experiments, but rather, purchase the cinnabar whole, and grind it "as much as you can—if you were to grind it for twenty years, it would be but the better and more perfect." Achieving this brilliant perfection leads to tremors, insanity, and death—caused by overexposure to mercury (cinnabar sheds quicksilver tears). Perhaps in sympathy, the fugitive red of vermilion eventually also escapes to black in sunlight.

Tom Norton

# Walnut Ink

I learned to draw at an art school in the sixties using a viscous brown drawing ink. After graduate school, I gradually drifted away from drawing per se, working in theater, photography, and eventually computer graphics. Then a few years ago, my interests brought me back to drawing, so I went out to try to find some of that brown drawing ink. I looked all over—but couldn't find it. I bought a bottle of every kind of brown ink I could find and found them all to be watery, and in tones that ranged from blackish brown to pink. The only thick inks were acrylic, which were somewhat opaque. And none of them were lightfast. So I decided to somehow make my own brown ink. Having mixed chemicals in photography and having made scenic paint in theater (from glue sizing and powdered pigment), the idea didn't daunt me. I did extensive research and eventually found some European ingredients that were suitable for my purpose. After some experimentation for proper proportions and designing my manufacturing process, I came up with an ink very close to what I remembered that "sixties ink" to be like. Encouraged by many fellow professional artists (who all loved the ink), I decided to go into business. I started twelve years ago, and I now sell in 225 stores across the country—and growing. I call my ink "Walnut® Drawing Ink."

People always ask me, "What is unique about your ink?"

First of all, it is entirely water-soluble; it has completely naturally derived ingredients, having an almost neutral pH of 8.8. It has a slight viscosity (from a water-based natural binder), which makes it hold well in a brush or hand-dipped pen. It has an extremely fine brown pigmentation, which lets you build a drawing by overlapping layers of washes. In this aspect it is like watercolor, but it comes in a consistent concentrated liquefied form that can be diluted for lighter tones. It is made from a naturally derived (proprietary) substance (not walnuts[61]), which is naturally this color (it's not just dyed water). And it is lightfast.

This ink has a unique, rich, warm color, and makes distinctive crisp marks on paper. Areas or lines made directly from the bottle produce dense, almost shiny marks. It has a certain "gutsiness" to it. Because it contains no shellac, varnish, or acrylic, it allows you to sustain longer drawings by softening up dark overworked areas of the page with clear water and lifting off the excess pigment with a dry brush, or for larger areas, a paper towel. This ink has been approved by a certified toxicologist and has its own MSDS (Materials Safety Data Sheet).

People also ask me if my ink can be used in fountain pens. It works well, but you should not store the ink in the pen. The binder and the fine pigmentation that give it its unique qualities will clog a fountain pen if let to sit for a time. You should also, after use, dip the pen tip in clear water and wipe it dry.

Spyros Papapetros

# inkWell

*First "I" for Immediacy*: One of ink's most enduring qualities is its immediacy, the instantaneous yet lasting intimacy it establishes with the surface upon which the liquid material spreads and permeates. From skin to paper, ink amalgamates fluid and solid matter to produce an object with an almost protean ability for transformation. In his 1856 lecture on adornment, Gottfried Semper notes that "[o]n certain social occasions, as Pliny expressly says, the Celtic maidens and wives would appear in blackface, as it were, with their whole bodies painted with blue-black ink (*den ganzen Körper mit Tinte Blauschwarz bemalt*) [ ... ] the celebrated bluestockings represent the last stage and refinement of this ancient British fashion."[62] For Semper, ink represents the origin of a tectonic layer that occasionally covers the body and ultimately mutates into a removable envelope—bluestockings—a type of netting that, following the architect's well-known theories of plaiting and cladding, informs the very matter, technique, and representational capacity of architecture in its various stages.

*Second "L" for Line*: Henry van de Velde is perhaps the most fervent proponent of such bodily immediacy established by drawing and tectonic processes. In several of his theoretical writings, he describes the origin of the line in bodily movements, specifically in the gestures of prehistoric men, whose astounding drawing achievements were recently discovered in the caves of Altamira.[63] Lines are direct extensions of the physiological and psychological excitation of the human or animal being, they are based on instinctive imitation and were originally free from any intellectual "reflection" or symbolic association. Similar to the ink streaks applied on the bodies of Celtic women that later (following Semper) transform into fabric threads, van de Velde's ornamental lines protract the bodily contour beyond its functional and organic periphery and crystallize the aerial substance of bodily movement into a permanent linear network. While tightly

interwoven with one another, the same cluster of lines can ambiently extend from surface ornaments to curvilinear furniture or building profiles. Whether drawn on a piece of paper or sculpted in wood and metal, the line's "dynamographic" capacity dwells in its ability to transpose the fluidity of organic processes into an inorganic material and thus to "animate" the inert drawing or artifact with a semblance of life.

*And Third "W" for InkWell*: What if the material (ink) and the medium (line), already hardly distinguishable from each other, ultimately merged into one object? Van de Velde's design for an inkwell (ca. 1898) embodies such fusion via the plastic contours of an ornamented artifact that materializes ink's protean capacity for animation.[64] Combining the storage with the use of ink, van de Velde's design artfully transposes the container and the contained, the anticipation and the actual act of writing or drawing. It is as if the liquid behavior of ink itself shapes the inkwell; in an empathetic twist, the viscous substance appears to spill out of its container to inform the rest of the artifact. Van de Velde's inkwell represents the materialization of a single continuous line that swerves, loops, and forms broad surfaces or pockets of space with its meandering pathway. It is an artifact with no discernible center or direction: in its combination of the upright cylindrical container and the broad curvilinear base, it merges verticality with horizontality while amalgamating the substance of ink with its formal reflection. While van de Velde does not desire artists to think or reflect on their designs, his objects manifest an almost animistic intelligence. The inkwell displays an ingenuity produced by the correspondence of the artifact's lines and the communication of its forms as they echo both each other and the curvatures of a living body. This is not only a writing tool but also a musical instrument producing reverberations between the several parts of the artifact and its milieu. In fact, the greatest feat of van de Velde's inkwell is the ostensible reversal between object and environment that it effects; it echoes mimicry formations in the natural world, as when animal or vegetal bodies gradually acquire the morphological properties of their surroundings. The formal pattern of the inkwell emulates the movement of ink spreading, not over a solid material plane like paper but inside a liquid substance such as water, similar to the emanations of ink from a squid in the ocean. Liquid extending inside another liquid: this is the subtle epistemological reversal performed by van de Velde's bronze inkwell, which rehearses ink's resolute extensibility from writing to drawing and to architecture. Drawing from the morphological transgressions of the previous fin-de-siècle, we now live in a world of animate communication in which distinctions between subjects and objects are no longer solid—a universe of infinite communication in which the coded information of ink retraces the evolution of our own animate being and the primordial desire for extension within a slowly ossifying milieu.

## Gavin Browning

# X

X marks the spot: a weary traveler has arrived. He or she has successfully navigated untold obstacles along the dotted lines of a purloined pirate map. Buried there are treasures too dear to name. By marking the spot on parchment, rock, or earth, X propels a journey across physical and narrative space.

X is anything to everyone. Moonshine, pornography, treasure, Christ, poison—by marking spots, it allows meaning to go unmarked.

X is precious. Its value is measured in the length and sweat it took to get there—the harder we try to reach it, the more valuable it must be. In Stanley Kramer's 1963 film *It's a Mad, Mad, Mad, Mad World*, Spencer Tracy, Jonathan Winters, Milton Berle, Ethel Merman, Don Knotts, the Three Stooges, and countless others crisscross California in search of a fortune buried beneath "The Big W," an X so-outsized that it morphs into another letterform.

X is a variable. For Valerie Solanas, X found meaning next to Y. In the *SCUM Manifesto*, she writes that "[t]he male is a biological accident: the Y (male) gene is an incomplete X (female) gene, that is, it has an incomplete set of chromosomes."

X is destination, discovery, denouement. It marks the spot, but not the end.

## 沙心瓘
## Sha Xin Wei

# Sign(ature)

U and V rent a small boat and go fishing. After a while, U says to V, "This is a great spot for fishing." V says, "Yes, but how will we know to come back to this spot?" U takes a brush and draws an X in the bottom of the boat. "That's how!" V says, "That's silly; how do you know that they'll rent us the same boat tomorrow?"

So, "X" marks the spot. In Roman languages, "X" was the quintessential sign of here-ness. It was also the mark of I-ness in lieu of the more ideographic

mark that an analphabetic person could make as a legal signature. (Perhaps for Chinese it should be rather the rectangle 口 "kou" signifying mouth, which filled with the cross signifies 田 "tian"/paddyfield, or which filled with glyphs of the structures of cities signifies 國 "guo"/nation.)

In any case, what is a signature, and what does it do?

Derrida said in his celebrated essay, "Signature, événement, contexte" (1971) that writing, or any grapheme, breaks with every context. A grapheme's very persistence, its "iterability," detaches it from both reader and writer, from even the intentionality of the one who makes the mark. So, in deep senses, writing works by absence. That's not all. Not only is the boat unmoored, its subsequent inhabitants may make quite different uses of the "X." Vive la différence!

Imagine that U's boot had marked that "X" by chance, instead. U and V's conversation about it could still have happened. Or another conversation, equally sensible. Concerning writing in general, Derrida says, it is a "spacing as a disruption of presence in a mark"[65]; it works as a grapheme, even without referent fish, water, U or V.

Now suppose, nevertheless, that U and V wanted to affirm their good fishing here and now to an imagined fellow fisherman who may someday sit in this boat? Derrida says, "In order for the tethering to the source to occur, what must be retained is the absolute singularity of a signature-event and a signature-form: the pure reproducibility of a pure event."[66] But what is this pureness of the event of making that mark? Derrida makes no logical argument but slips into the waters of empiricism: "Effects of signature are the most common thing in the world."

Why not follow Derrida into the life world and into deeper waters? What if we slip from the problematic warrant of identity suggested by nuance, tone of voice, accent (whose conventional effect Derrida does not deny), to the processes themselves of nuancing, intoning, and accenting? What if we pass from predicating the signature that detachedly warrants "good fishing happened here" to the inking of the signature?

A more symmetrical, Simondonian account of this action would draw attention to the unbounded massing of material processes in the water, the ink, the wood, the fisherman's schooled hand dragged by the wood as it forms the mark, and the thousand years of concretization in that pen inextricably entwined with the evolution of associated technical crafts of ink, writing instruments, and orthography.

Supplementing J.D.'s "very dry discussion,"[67] let me ink my brush and stroke this tissue paper in a crisscrossing motion, watching the paper's fibers swell darkly for a moment as the ink suffuses them, then coalesce into pools

of black. I pour water after the ink, watching the water chase and diffuse the ink further into the paper's fibers. As the wet pools grow, the water stratifies what used to be a uniform black, separating out the hues. I smell the ink now as enough of the paper's surface has wetted to perfume the air. The spotting absorbs the X.

J. Yolande Daniels

# inky

"Inky" might refer to the seeping, leaking, and staining by certain gaseous or liquid substances in an architectural context and the mechanical systems that contain them to prevent possible contamination. In another architectural context, inky architecture "generates ink," as buildings and architects make news.

Despite the shrinking of print media, architecture can "eject liquid traces." Recognition relies on having "inky fingers"—on marking a trail with indelible impressions. Digital media have opened up new avenues for generating ink online from sites that feature project catalogs to theoretical musings.

This represents a shift in control of the conditions for generating ink from specialized and academic publications. Inky architecture is anarchistic. It lacks centralized control of posts or content. Online publishers are numerous and globally situated. Although inky architecture has the potential to open up architectural criticism, at present, the dominant criticism online is the equivalent of a "Like."

The conditions for inky architecture require a saturation of the media with a product. The architectural product may be either built or unbuilt. While thirst for the novel conceit may be epitomized in the unbuilt project, unbuilt work has a fixed number of images that are controlled by the producer and/or their publisher/agent with which to create traction. For a built project, the possibilities to become inky are greater and more lasting, and, the conditions for documentation are broader.

As long as interest remains, architectural tourists may continue to add to the liquidity of a project. With the reposting of information onto sites secondhand, the control of images and information regarding a project may further eclipse the producer and agent. Should architecture continue to spread from specialized to popular browsers by going viral, it could become truly "inky."

Le Corbusier

# Zip-a-tone

"Zip-a-tone" is a product recently placed at the disposal of draughtsmen, photographers, and commercial artists. It consists of transparent cellophane sheets covered by different patterns printed in black. Here, the first pattern is a regular set of points; the second a regular set of lines; the third, a combination of the two. To play the game (an unexpected one) which I am suggesting, it is enough to take the first fragment of "Zip-a-tone" that comes to your hand, put it on top of another, and turn it very slightly from left to right or from right to left. You will see that, within less than one-quarter of one rotation, you will have determined seven different drawings of a hexagon. It happens under your very eyes: within a second you see a thrilling geometrical phenomenon come to life and develop. But if, in turning your cellophane sheet, you do not stop at the right stages there will be no geometry; you will be left outside the door, in a world of inconsistency.

This phenomenon of interference denounces the hiatus as much as it demonstrates perfection. It all depends on you or on the circumstances in which you read, your lack of attention or a minute displacement of an object. The wealth of the world consists precisely in these infinitely fine nuances which vulgar man forgets to see because he imagines a wealth that is spectacular, noisy, torrential … dwelling only in privileged places, inaccessible to modest folk. It is enough to observe.[68]

Appendices
# Abecedary Precedents
Footnotes

Contributor Bios

### Apollinaire, Guillame
*Calligrammes, poèmes de la paix et de la guerre 1913–1916*, 1918.

### Baldessari, John
*Alphabet*, Art Basel, 2009.

### Baldessari, John
*Teaching a Plant the Alphabet*, 1972.

### Beinecke
*New Political Alphabet, or A Little Book for Great Boys.*
Samuel Webb, 1813.

### Bouwkunde, Afdeling
*ABC, Beitrage zum Bauen 1924–1928.* Technichse Hogeschool Eindhoven, 1969.

### Cage, John
*An Alphabet (play for James Joyce, Marcel Duchamp, Erik Satie)*, 2003.

### De Caumont, M.A.
*Abecedaire du Rudiment D'Archelogie.* Oxford University, 1850.

### Deleuze, Giles
*Abecedaire.* Directed by Pierre-André Boutang with Claire Parnet, 1988–89.

### Elser, Elizabeth
*Alphabet: Pointes Seches D'Elizabeth Elser.* Georges LeBlanc, 1957.

### Filliou, Robert (Fluxus)
*Standard Book.* Dieter Roth, 1981.

### Gorey, Edward
*The Eclectic Abecedarium.* Adama Books, 1985.

### Gorey, Edward
*The Gashleycrumb Tinies* in *The Vinegar Works: Three Volumes of Moral Instruction.* Simon and Schuster, 1963.

### Hockney, David
*Hockney's Alphabet.* Random House, 1991.

### Jackson, Trevor
*TCD BCCKS.* The 20th Anniversary Edition, 2007.

### Johns, Jasper
*Grey Alphabet*, 1956.

### La Porte, Rene
*Alphabet de l'Amour avec une image de Valentine Hugo.*
Editions G.L.M., 1935.

### Ligeti, Gyorgy
*Aventures*, 1962.

### Lupton, Ellen
*The ABCs of the Bauhaus and Design Theory.* Thames and Hudson, 1993.

### Marinetti, F.T. et Fillia
*Cucina Futurista* (edible alphabet). Turin, 1929.

### McLuhan, Marshall
"Alphabet: Mother of Invention." *Etcetera*, Vol. 34, 1977.

### Michaux, Henri
*Alphabet*, 1927.

### Moholy-Nagy
*Opto-Acoustic Alphabet, Sound ABC, Tonenedes ABC*, 1932.

### Pound, Ezra
*ABC of Reading.* Yale University Press, 1934.

### Price, Matlock
*The ABC of Architecture.* E.P. Dutton & Co., 1927.

### Rose, Barbara
"ABC Art." *Artforum*, October 1965.

### Ruscha, Ed
*Edward Ruscha: Cityscapes / O books + S books. Two Volumes.*
Leo Castelli Gallery, 1997.

### Ruscha, Ed
*TwentySix Gasoline Stations.* National Excelsior Press, 1967.

### Russell, Bertrand
*The Good Citizens Alphabet* with illustrations by Franciszka
Themerson, 1953.

### Uruquhart, Donald
*An Alphabet of Bad Luck, Doom and Horror*, 2004.

*Visionaire*, 10.

### Wegman, William
*ABC.* Hyperion Books, 1994.

**1**

Henri Michaux, *Stroke by Stroke*, (New York: Archipelago Books, 2006), 1.

**2**

Wil Roebroeks, Mark J. Sier, Trine Kellberg Nielsen, Dimitri De Loecker, Josep Maria Parés, Charles E. S. Arps, and Herman J. Mücher, "Use of red ochre by early Neanderthals," in *Proceedings of the National Academy of Sciences of the United States of America* (January 23, 2012).

**3**

Zhang Xu, in *Tang Shi San Bai Shou* (*300 Tang Poems*), a compilation of poems from this period made around 1763 by Heng-tang-tui-shi (Sun Zhu) of the Qing dynasty.

**4**

Chiang Yee, *Chinese Calligraphy*. (London: Methuen, 1955).

**5**

Partners, Taalman and Koch left OpenOffice in May 2002, Dia:Beacon was completed in May 2003, and I continued at SAS from 2004 on.

**6**

Kate McCrickard, "I Am the Bird Catcher" in *William Kentridge: Flute*. ed. Bronwyn Law-Viljoen (Johannesburg: David Krut Publishing, 2007), 127–8.

**7**

Ibid.

**8**

George Nakashima, *The Soul of a Tree, A Woodworker's Reflections* (Tokyo, 1981), 178.

**9**

"NASA's Spitzer Reveals First Carbon-Rich Planet," http://www.nasa.gov/mission_pages/spitzer/news/spitzer20101208.html.

**10**

"Diamond–Tipped Cane" http://www.wowhead.com/item=45861/diamond-tipped-cane.

**11**

In a letter Jane wrote to her sister, Cassandra, on October 14, 1813.

**12**

Pelikan Graphos india ink drawing pen and nib set, 1934–1957 © Pelikan Vertriebsgesellschaft mbH & Co. KG.

**13**

Diderot. *Encyclopedie*, 1ere edition, tome 8.dj vu/21.Wikisource, //fr.wikisource.org/w/index.php?title=Page:Diderot_-_Encyclopedie_1ere_edition_tome_8.djvu/21&oldid=3798355 (Page consultée le novembre 28, 2012).

**14**

Excerpt from Martin Gayford, "Written With the Body," the *Telegraph*, May 21, 2005.

**15**

Excerpt from Pavitra Jayaraman, "1937 Mysore Paints and Varnish | The ink of Democracy," LiveMint.com, HT Media Incorporated, August 13, 2012.

**16**

Mark Wigley at the "Ink" dialogues held in conjunction with "Ink," an exhibition of works by Michelle Fornabai, Studio-X, New York City, January 28, 2010.

**17**

Example of Black Scripture [*Siyah Mashgh*, مشق سیاه] by Mirza Reza Kalhor.

**18**

Models Marisa Berenson and Cynthia Korman Captured in Isfahan, Iran by Henry Clarke © *Vogue* magazine.

**19**

*Woman of Allah* © Shirin Neshat.

**20**

*Nothing* © Parvis Tanavoli.

**21**

Fyfe, Sophie, Claire Williams, Oliver J. Mason, and Graham J. Pickup, "Apophenia, theory of mind and schizotypy: Perceiving meaning and intentionality in randomness," *Cortex 44* (2008), 316.

**22**

Elvin, Mark. "Personal Luck: Why the Chinese—probably—did not develop probabilistic

thinking," 32 (PDF), published in *Chinese Science and the Scientific Revolution* (in Chinese), ed. Liu Dun, 2002.

**23**

Ibid.

**24**

Ibid.

**25**

Fyfe, 317.

**26**

Armstrong offered the following self-portrait in an address to America's National Press Club in 2000.

**27**

Excerpt from Peter Galison, "Image of Self" in *Things That Talk: Object Lessons from Art and Science*, edited by Lorraine Daston (New York: Zone Books, 2004), 257.

**28**

Rorschach to Morgenthaler, April 18, 1921, RMC.

**29**

Rorschach, galley-proof corrections of cards, Rorschach Archives, Bern

**30**

Galison, "Image of Self," 271.

**31**

Mark N. Resnick and Vincent J. Nunno, "The Nurenberg Mind Redeemed: A Comprehensive Analysis of the Rorschach's of Nazi War Criminals," *Journal of Personality Assessment*, 57, no.1 (1991), 1929. There is a moral-epistemic chasm that opens as one sees the apparatus of experimental psychology attempting to assess a group that included Hermann, Goering, Alfred Rosenberg, Albert Speer, and Arthur Seyss-Inquart. On the one hand, the authors judged that the group was lacking in introspection; "average German citizens-products of a rigid, paternalistic, male-dominated society [with] mildly paranoid features [but] no evidence of thought disorder or psychiatric condition." On the other hand, they were "character-disordered criminals" of a type that is "not rare," indeed commonly found in "the upper echelons of most closed systems...civil service, government,

intelligence agencies, the military, and the large public and private companies" [27-28].

**32**

Galison, "Image of Self," 290-91.

**33**

George Adams, "Geometrical and graphical essays, containing a description of the mathematical instruments used in geometry, civil and military surveying, leveling and perspective," (London: printed for the author, by R. Hindmarsh, 1791), 14–15.

**34**

Maya Hambly, *Drawing Instruments, 1580–1980* (London: Sotheby's Publications, 1988), 11.

**35**

Lois Olcott Price, *Line, Shade and Shadow: The Fabrication and Preservation of Architectural Drawings* (New Castle, DE: Oak Knoll Press; Houten, Netherlands: HES & DE GRAAF Publishers; Wilmington, DE: Winterthur Museum and Garden & Library, 2010), 11–13. For more on the history and uses of the ruling pen, see Howard Dawes, *Instruments of the Imagination: A History of Drawing Instruments in Britain 1600–1850* (Worcestershire: Dawes Trust, 2009) and Susan C. Piedmont-Palladino, ed., *Tools of the Imagination: Drawing Tools and Technologies from the Eighteenth Century to the Present* (New York: Princeton Architectural Press, 2007).

**36**

Hambly, 61.

**37**

Ibid.

**38**

Translator's note: 水墨, literally "water" and "ink" broadly refers to ink made of ground pine or oil soot mixed with water. Developed as a painting medium in the Tang Dynasty (618–907), the application of ink to paper with various brush types and in a range of densities as shuimohua (ink painting) has occupied a central place in the Chinese artistic canon.

**39**

Translator's note: Developed in the Tang Dynasty prefecture of Xanzhou, part of modern-day

Anhui Province, Xuan paper contains elm bark and can also include rice, bamboo, and mulberry pulp, and a variety of other ingredients. Supple and soft, Xuan paper is ideal for Chinese ink painting and calligraphy.

**40**

Translator's note: "Brush and Ink Equal Zero" is the title of a 1992 essay by renowned Chinese painter Wu Guanzhong (1919–2010), the culmination of a debate between critics and practioners of Chinese painting about the importance of innovation and expression in this medium.

**41**

Author's note: There was heated debate in the art world of 1980s China about the definition of *bimo* ("brush" and "ink").

**42**

See *One Week*, 1920, directed by Eddie Cline and Buster Keaton.

**43**

"Buster Keaton," Wikipedia, http://en.wikipedia.org/wiki/Buster_Keaton.

**44**

Landergan, Katherine and Jenna Duncan, "Ink spill on I-95 shuts down an on-ramp near Boston and forces repaving," the *Boston Globe*, March 10, 2011.

**45**

See *Marnie*, 1964, directed by Alfred Hitccock.

**46**

See *L'Avventura*, 1960, directed by Michelangelo Antonioni.

**47**

Charles Rosen and Henri Zerner, *Romanticism and Realism: The Mythology of Nineteenth-Century Art* (New York: Viking Press, 1984), 222.

**48**

Ibid.

**49**

Ibid., 223.

**50**

Meyer Schapiro, "Recent Abstract Painting" (originally titled "The Liberating Quality of Avant-Garde Art"), in Schapiro, *Modern Art: Nineteenth and Twentieth Centuries, Selected Papers* (New York: George Braziller, 1978), 213–216.

**51**

Ibid., 218.

**52**

Robert Motherwell, 1951, source not given, cited in an exhibition catalogue at the Stadtische Kunsthalle, Dusseldorf, 1976, excerpted in Dore Ashton, ed., *Twentieth-Century Artists on Art* (New York: Random House/Pantheon, 1985), 235.

**53**

Philip Guston, statement, in *It Is*, No. 5 (Spring 1960): 36–38.

**54**

Excerpt from Caroline A. Jones, "The Romance of the Studio and the Abstract Expressionist Sublime," in *The Machine in the Studio: Constructing the Postwar American Artist* (Chicago: The University of Chicago Press, 1996), 9–11.

**55**

Buckminsterfullerene (or buckyball) is a spherical fullerene molecule with the formula $C_{60}$. It has a cage-like fused-ring structure (Truncated icosahedron), which resembles a soccer ball, made of twenty hexagons and twelve pentagons, with a carbon atom at each vertex of each polygon and a bond along each polygon edge.

**56**

Akira Yamasaki, Takeshi Iizuka, and Eiji Osawa. "Fullerenes in Chinese Ink Sticks ("Sumi")," in *Fullerene Science & Technology*, Volume 3 (Issue 5), 1995, 529. Reproduced by permission of Taylor & Francis Group, LLC (http://www.tandfonline.com).

**57**

Adolf Loos, "Ornament and Crime," first spoken in a lecture on January 21, 1910, in Vienna and first published in *Cahiers d'aujourd'hui* 5/1913.

## 58
Day, Sean A. "Trends in Synestically Colored Graphemes and Phonemes." Department of English and Journalism, Trident Technical College, Charleston, S.C., 2004.

## 59
Vitruvius, "The Decadence of Fresco Painting," in Book VII, Chapter V, Section 8, in *The Ten Books of Architecture*, translation by Morris Hickey Morgan. (Cambridge: Harvard University Press, 1914), 213.

## 60
Vitruvius, "Cinnabar (continued)," in Book VII, Chapter IX, Section 1, in *The Ten Books of Architecture*, translation by Morris Hickey Morgan. (Cambridge: Harvard University Press, 1914), 216–218.

## 61
Real "walnut ink," used for centuries, is not only very acidic, but it's also a black ink. Furthermore, being a vegetable dye, it's not lightfast and only fades to those wonderful brown tones after many years.

## 62
Gottfried Semper, "From Concerning the Formal Principles of Ornament and Its Significance as Artistic Symbol," translation by David Britt, *The Theory of Decorative Art: An Anthology of European and American Writings, 1750–1940*, ed. Isabelle Frank (New Haven: Yale University Press, 2000), 93. For the original German text of Semper's 1856 lecture, see "Über die formelle Gesetzmässigkeit des Schmuckes und dessen Bedeutung als Kunstsymbol" in Gottfried Semper, *Kleine Schriften*, ed. Hans and Manfred Semper (Berlin and Stuttgart: W. Spemann, 1884), 308.

## 63
In particular, see his incomplete essay on ornament as well as his published essay on the line: Henry van de Velde, "Manuscript on Ornament" translation by Elie G. Haddad and Rosemarie Anderson, *Journal of Design History,* Vol. 16, No. 2, 139–166; and Henry van de Velde "Die Linie" in *Essays* (Leipzig: Insel Verlag, 1910), 41–74.

## 64
Henry van de Velde, *inkwell (Tintenfass)*, dated 1898. Two specimens exist, the first is without a cap and measures 20 × 9.1 × 5 cm, 581 grams, of copper and bronze, currently held at the Design museum Gent. The second artifact has a cap, measures 22 × 10.5 × 5.8 cm, 699 grams, is made of copper, bronze and brass, and is held at the Nordenfjeldske Kunstindustrimuseum in Trondheim. The inkwell was included in the Secession exhibition in Munich (1899) and the show "La Libre Esthétique" in Brussels (1900). See Volume 1, "Metallkunst" of *Henry van de Velde: Raumkunst und Kunsthandwerk*, ed. Thomas Föhl and Antje Neumann (Leipzig: Seemann, 2009), 128–129. For the Secession catalogue listing, see Wolf D. Pecher, *Henry van de Velde, das Gesamtwerk*, (Munich: Factum, 1981) 143. The inkwell is also mentioned in Klaus-Jürgen Sembach and Birgit Schulte, *Henry van de Velde: Ein europäischer Künstler seiner Zeit* (Koln: Wienand, 1992), 162, and in *Karl-Heinz Hüter, Henry van de Velde, Sein Werk bis zum Endeseiner Tätigkeit in Deutschland* (Berlin: Akademie-Verlag, 1967), 92. Further specimens of van de Velde's inkwell are documented in Klaus-Jürgen Sembach's inventory of holdings at the van de Velde archive at La Cambre, Brussels, Belgium.

Henry van de Velde, *Inkwell*, 1898. Photo: Alexander Burzik (Klassik Stiftung Weimar) © Design museum Gent

## 65
Derrida, Jacques. "Signature, Event, Context," 1971. translated by Alan Bass. Margins of Philosophy (Chicago: The University of Chicago Press, 1982), 19.

## 66
Ibid, 20.

## 67
Ibid, 21.

## 68
Le Corbusier. *Modulor 2* (Faber and Faber, 1958), 153.

## Ariza Medrano, Martin

Martin Ariza Medrano is a Spanish poet and playwright from Cadiz, Spain. He is currently working in television production in Madrid.

## Bald, Sunil

Beginning as Louis I. Kahn visiting assistant professor, Sunil Bald has been on the faculty at Yale since 2006, where he teaches design studios and visualization. Bald is a partner in the New York–based Studio SUMO, which has been featured as one of *Architectural Record*'s "Design Vanguard" and the Architectural League of New York's "Emerging Voices." His firm has received a Young Architects award from the Architectural League and an NYFA fellowship, and was a finalist in the Museum of Modern Art's Young Architects program. SUMO's work, which ranges from installations to institutional buildings, has been exhibited in the National Building Museum, MoMA, the Venice Biennale, the Field Museum, the GA Gallery, and the Urban Center. Bald has an enduring research interest in modernism, popular culture, and nation-making in Brazil, for which he received fellowships from the Fulbright and Graham Foundations and published a series of articles.

## Balmet, Gilles

Gilles Balmet is an artist who was born in La Tronche, France, in 1979. He graduated Grenoble art school in 2003 and has lived in Paris since 2004. He owns studios in Paris and Grenoble, where he constantly works on different processes using India ink, Japanese ink, spray paint, acrylic, and a lot of new tools he develops to elaborate new ways of representing mental images. Painter, drawer, photographer, his work uses different mediums to question the boundaries between abstraction and landscape depiction, and possible links between drawing, painting, and photography. He develops paintings on paper using basins of matter and swimming pools in which he creates images that look like photorealistic renditions of landscapes by using and trying to control the aleatory of the matter. Balmet is interested by the genealogy of all the series of works he creates, and he uses the hybridation of the different processes he elaborates during his studio sessions to create new works. He has exhibited his works in numerous museums, art centers, and galleries worldwide. He lived six months in 2010 in Kyoto, Japan, with Benoît Broisat at Villa Kujoyama, a famous French artist residency program. He was appointed in 2012 as an artist-teacher in Ecole Supérieure des Beaux Arts in Montpellier in the south of France. He is represented by Galerie Dominique Fiat in Paris.

## Benjamin, David

David Benjamin is founding principal at architecture firm The Living, and director of the Living Architecture Lab at Columbia University Graduate School of Architecture, Planning and Preservation. The practice and the lab explore new technologies and create prototypes of the architecture of the future. Recent projects include "Living City" (a platform for buildings to talk to one another), "Amphibious Architecture" (a cloud of light above the East River that changes color according to water quality and collective interest in the environment), and "Bio-Computation" (a new process for using biological algorithms and bacterial manufacturing to create sustainable building materials through synthetic biology). Before receiving a master of architecture degree from Columbia, Benjamin graduated from Harvard with a BA in social studies.

## Berman, Ila

Ila Berman, professor and director of architecture at the California College of the Arts (CCA), is an architect and theorist with a doctorate from Harvard University's Graduate School of Design. Berman is the recipient of many awards and honors including the Lieutenant Governor's Medal for Design, Social Sciences and Humanities Research Council of Canada Fellowships, AIA Awards, and the President's Award at Tulane University. Berman's design work and publications on architecture, urbanism, and media include the book *URBANbuild local global* (co-authored with Mona El Khafif), winner of an AIGA Award for the top 50 books of 2009; "Amphibious Territories" in the *AD Territory: Architecture Beyond Environment*; Material Folds + Crystalline Fractures" in *Next AEDS*, a book series on global emergent practices in the field of digital design; *New Orleans: Strategies for a City in Soft Land* by Harvard University (with Joan Busquets and Felipe Correa); and *Sustainable Skyscrapers: Vertical Ecologies and Urban Ecosystems*, as well

as writings in *Praxis*, *APPENDX*, *GAM.07 Zero Landscape*, *JAE*, and the *Cornell Journal of Architecture*, among others. In addition to her installations at the Contemporary Art Center, the Ogden Museum, the Perloff Gallery, and other public and private institutions, she was also the creator of "Urban Operations for a Future City," an exhibition at the 2006 International Architectural Biennale in Venice, Italy, and the recent project "WBA3: Architecture in the Expanded Field," an installation designed for the Wattis Institute of Contemporary Art in San Francisco.

## Bridgeman, Martin

Martin Bridgeman is a professor of mathematics at Boston College. He was born in Dublin, Ireland, and received his BA in mathematics at Trinity College Dublin where he was a foundation scholar and gold medalist. He received his doctorate in mathematics from Princeton University in 1994. Bridgeman has received numerous grants from the National Science Foundation and has published many articles in mathematics. He was a Simons fellow, a Van Vleck Fellow, and has been a visiting professor at Institut Henri Poincare, Paris, France; the Institut des Hautes Etudes Scientifiques, Bures-sur-Yvette, France; Toulouse University, Toulouse, France; National University of Singapore, Singapore; Centre de Recerca Matematica, Barcelona, Spain; Massey University, Auckland, New Zealand; and the Mathematical Sciences Research Institute, Berkeley, California. His research is focused on hyperbolic geometry, geometric analysis, and dynamics. Bridgeman also founded the William Rowan Hamilton Geometry and Topology Workshop, an annual workshop held at Trinity College Dublin.

## Browning, Gavin

Gavin Browning is director of events and public programs at the Graduate School of Architecture, Planning and Preservation (GSAPP) of Columbia University. Previously, he directed Studio-X New York, where he organized events and exhibitions, and edited *The Studio-X New York Guide to Liberating New Forms of Conversation* (GSAPP Books, 2010). He holds an MS in urban planning from Columbia University and a BA in English from The New School University.

## Bryan, Babak

Babak Bryan, AIA, is a registered architect and a graduate engineer. In addition to his design practice that explores the integration of these two disciplines in built form, he is dedicated to an academic pursuit of the latent potentials within digital generation. He currently teaches at the City College of New York and has previously taught at the Graduate School of Architecture, Planning and Preservation at Columbia University, the University of Pennsylvania, and Parsons.

## Carpenter, Amy

Amy Carpenter is an artist and writer who lives in Boston, Massachusetts, with her husband, two dogs, and a parakeet named Dan. She attended the Massachusetts College of Art and Design where she majored in sculpture, as well as in video and event production in the Studio for Interrelated Media (S.I.M.). Carpenter now creates videos for Puma and has worked with both Usain Bolt and the Puma Ocean Racing Team in the Volvo Ocean Race. She is currently interviewing, shooting, and editing videos of Team Oracle in the America's Cup. Her own grandfather never ran over a tortoise with a lawnmower.

## Cohen, Alexis H.

Alexis H. Cohen is a PhD candidate in the Department of Art & Archaeology at Princeton University studying eighteenth- and nineteenth-century architectural history. Her dissertation examines the proliferation of the outline drawing ca. 1800 within British and French archaeological, architectural, and interior design publications and explores how this graphic idiom illuminates neoclassicism's replication and modeling strategies in the context of emerging practices of industrial manufacture. Her work has been supported by the Social Sciences and Humanities Research Council of Canada and the Deutscher Akademischer Austausch Dienst. She received her BA in art history and English literature from the University of Toronto in 2006.

## Costello, Craig "KR"

Craig Costello, aka "Krink" or "KR," is one of the most visionary and inspirational street artists working today and is also the creator of KRINK, a line of the finest quality handmade inks and markers, beloved by artists and vandals alike.

## Daniels, J. Yolande

J. Yolande Daniels received architecture degrees from Columbia University and City College, CUNY. She was a recipient of the Rome Prize in Architecture from the American Academy in Rome, received a travel grant from the New York chapter of the American Institute of Architects and fellowships at the MacDowell Colony and the Independent Study Program of the Whitney American Museum of Art, where she was a Helena Rubinstein fellow in Critical Studies. She has taught architecture at universities including the Graduate School of Architecture at Columbia University and Massachusetts Institute of Technology. She is also a design principal of studioSUMO, an architecture office founded in 1995 that is located in New York with projects in the United States, Japan, and Brazil. studioSUMO has been the recipient of various awards including Emerging Voices, Design Vanguard, and Young Architects Forum as well as the recipient of grants such as New York State Council on the Arts and New York Foundation for the Arts.

## Day, Sean A.

Sean A. Day holds a BA and MA in anthropology, and a PhD in linguistics. He currently holds a joint position in the Department of English and Journalism and the Department of Behavioral and Social Sciences at Trident Technical College, in Charleston, South Carolina, where he teaches anthropology. A multiple synesthete himself, he has interacted with other synesthetes for over forty years. He is the founder and moderator of the Synesthesia List, an e-mail forum for synesthetes and researchers, which he has maintained for over 20 years. He has given talks regarding synesthesia in Belgium, France, Germany, Russia, Spain, Taiwan, and the UK, as well as in the US and Canada. He has been president of the American Synesthesia Association since its inception as nonprofit organization.

## Feng, Qin

Born in Xinjiang, China, Qin Feng's work is deeply influenced by his experience growing up on the steppes of that westernmost part of China. His experiences living in Germany and the U.S. have also shaped his thinking on issues of boundaries, both artistic and cultural, and on civilizations, power, and traditions, which is reflected in his works. Founder and director of the Museum of Contemporary Art, Beijing, Qin Feng also teaches at the Central Academy of Fine Arts in Beijing and is a research associate in the Fairbank Center for Chinese Studies at Harvard University. Qin Feng has shown at major museums, and his works have been collected by the Metropolitan Museum of Art; Museum of Fine Arts, Boston; and the National Arts Foundation (France), among many others.

## Finley, Karen

Karen Finley is an artist, performer and author. Born in Chicago, she attended the Chicago Art Institute growing up and received her MFA from the San Francisco Art Institute. She works in a variety of mediums such as installation, video, performance, public art, visual art, music, and literature. She has performed and exhibited internationally. Finley is also interested in freedom-of-expression concerns, visual culture, and art education, and lectures and gives workshops widely. She is the author of eight books, including her latest work of creative nonfiction: *Reality Shows* published by Feminist Press in 2011. She is the recipient of many awards and grants, including a Guggenheim Fellowship. Finley works in ink as a way to refresh and examine more closely ideas and concepts from page to stage and back. She is an arts professor in art and public policy at New York University.

## Fornabai, Michelle

Michelle Fornabai received her master's of architecture from Princeton University. Her work has been exhibited at the Whitney Museum of American Art at Altria; Storefront for Art and Architecture in New York; the Contemporary Art Center in New Orleans; and in Beijing, China, at Studio-X Beijing. Her work has been reviewed in the *New York Times* and *Frieze Magazine*. She currently teaches at the Graduate School of Architecture, Planning and Preservation at Columbia University, having taught previously at RISD, UCLA, and Tulane University. She has lectured at the Whitney Museum, the ICA in Philadelphia, the San Francisco Art Institute, the Fashion Institute of Technology, and for the Merce Cunningham Dance Foundation. Her practice, ambo.infra design, was established in 2001. Her recent work in ink, *Rorschach Paintings*, *Projective Drawings*, and *Concrete*

*Poetry: 10 Conceptual Acts of Architecture in Concrete*, explores pattern perception and its relation to figuration and abstract order.

## Galison, Peter

Peter Galison is the Joseph Pellegrino University professor of the history of science and of physics at Harvard University. His work explores the complex interaction between the three principal subcultures of physics—experimentation, instrumentation, and theory, and their embedding in politics and materiality. Among his books are: *How Experiments End* (1987), *Image and Logic: A Material Culture of Microphysics* (1997), *Einstein's Clocks, Poincaré's Maps* (2003), *Lorraine Daston, Objectivity* (2007), and (among other co-edited volumes) *The Architecture of Science, Picturing Science, Producing Art, Scientific Authorship, Atmospheric Flight in the Twentieth Century*, and *Einstein for the 21st Century*. To explore the relation of scientific work with larger issues of politics, he has made two documentary films: *Ultimate Weapon: The H-bomb Dilemma* (2000), and, with Robb Moss, *Secrecy* (about national security secrecy and democracy), which premiered at the Sundance Film Festival in 2008. At present, he is completing a book, *Building Crashing Thinking* (on technologies that re-form the self) and has begun a new documentary film project on the long-term storage of nuclear waste, *Containment*.

## Gayford, Martin

Martin Gayford writes prolifically about art and music, contributing regularly to newspapers, magazines, and exhibition catalogues. He was art critic of the *Spectator* and the *Sunday Telegraph* before becoming chief art critic for *Bloomberg News*. His book about Van Gogh and Gauguin in Arles, *The Yellow House* (2005) was published in Britain and the United States to critical acclaim. *Constable in Love*, a study of John Constable's romance with Maria Bicknell, and their lives between 1809 and 1816 was published in 2009. His portrait by Lucian Freud has been exhibited at the Correr Museum, Venice; the Museum of Modern Art, New York; the National Portrait Gallery, London; and Museum of Modern Art, Fort Worth, Texas. His subsequent book about the experience posing for Lucian Freud, also titled *Man with a Blue Scarf*, was published in 2010. Martin Gayford's latest book,

*A Bigger Message: Conversations* with David Hockney, appeared in October 2011.

## Jacob, Wendy

Wendy Jacob is an artist whose work bridges traditions of sculpture, invention, and design. Her projects include walls and ceilings that breathe, tightropes rigged through living rooms, and floors that resonate with sub-audible vibrations. Her work has been shown at the Centre Georges Pompidou, Kunsthaus Graz, Whitney Museum of American Art, and the Museum of Contemporary Art, San Diego. In 2011, Jacob was awarded the Maud Morgan Prize by the Museum of Fine Arts, Boston. Jacob lives and works in Cambridge, Massachusetts.

## Jayaraman, Pavitra

Pavitra Jayaraman is a Bangalore-based features writer who presently works with Mint, the business paper of HT Media Ltd. She started her career as a television news correspondent for New Delhi Television Limited (NDTV), where she covered a range of topics including health, science, and politics and then moved to print journalism in 2007. Jayaraman writes on a range of topics including culture, travel, and music and has written several stories on the fast-changing city that Bangalore, India, is. Jayaraman traveled to Mysore, 140 kilometers from Bangalore, to pursue this story on Mysore Paints and Varnish Limited, a factory that was set up before India became independent but continues to have great relevance to the Indian democracy.

## Jones, Caroline A.

Caroline Jones teaches contemporary art and theory; her work focuses on technology, the body, and visual art in its many modes of production and circulation. She is currently director of the history, theory, and criticism section of the Department of Architecture at MIT. She received an AB in fine arts from Harvard-Radcliffe in 1977 and worked in the museum field for many years, serving as an administrator at the Museum of Modern Art in New York, and assistant director for curatorial affairs at the Harvard University Art Museums. After studying at New York University's Institute of Fine Arts, she received her PhD from Stanford University in 1992. Producer/director of two documentary films and curator of many exhibitions, her books

include major museum publications, such as *Modern Art at Harvard* (Abbeville, 1985) and *Bay Area Figurative Art, 1950–1965* (University of California Press, 1990), the award-winning *Machine in the Studio*: *Constructing the Postwar American Artist* (University of Chicago Press, 1996/98), and the co-edited volume *Picturing Science, Producing Art* (Routledge, 1999). Her most recent books include *Eyesight Alone*: *Clement Greenberg's Modernism and the Bureaucratization of the Senses* (Chicago 2005/08); *Sensorium*: *Embodied Experience, Technology, and Contemporary Art* (as editor, MIT Press, 2006). Fellowships in Berlin, Paris, and at the Newhouse Humanities Center have helped her work on the next book, titled *Desires for the World Picture: The Global Work of Art.*

## Juchmes, Roland

Roland Juchmes is a professor at the École Supérieure des Arts St.-Luc of Liège, Belgium. He lectures on building materials, construction technology, and computer-aided design to interior design and industrial design students. He is also a researcher at the University of Liège. His research interests focus on 3-D modeling and digital design in preliminary architectural design.

## Klein, Karel

Karel Klein is an architect and director of Ruy Klein, a widely published and award-winning design firm in New York City. Investigating craft, precision, and the evolution of design expertise in the digital age, Klein's work foregrounds the persistence of the designer in contemporary culture. In addition to degrees in architecture, Klein also received a degree in civil engineering from the University of Illinois Urbana–Champaign. Klein currently teaches at Pratt Institute and Columbia University.

## Leclercq, Pierre

Pierre Leclercq is a professor at the Department of Architecture, Faculty of Applied Sciences, University of Liège (ULg), Belgium. Founder of the Lucid laboratory (Lab for User Cognition and Innovative Design), he leads a multidisciplinary team of a dozen researchers from the fields of engineering design (architectural engineering), computer science (artificial intelligence), and psychology (cognitive ergonomics) around research and development projects in

the field of design. He is active in the research communities of design computing and cognition, human-computer interaction and sketch-based interfaces, and modeling.

## Martinez, Diana

Diana Martinez is a PhD candidate in architectural history and theory at Columbia University. She has taught both design courses and history courses at Barnard College, Columbia University and Pratt Institute. She holds a BA in architecture from UC Berkeley and received a master's of architecture from Columbia University. Diana's current research on concrete colonialism investigates the role building materials played in governance during the American colonial era in the Philippines (1898–1945).

## Mayne, Thom

Thom Mayne founded Morphosis as an interdisciplinary and collective practice involved in experimental design and research in 1972. Mayne is co-founder of the Southern California Institute of Architecture and distinguished professor at UCLA Architecture and Urban Design. Mayne's distinguished honors include the Pritzker Prize (2005). He was appointed to the President's Committee on the Arts and Humanities in 2009, and was honored with the American Institute of Architects Los Angeles Gold Medal in 2000. With Morphosis, Mayne has been the recipient of 25 Progressive Architecture Awards, more than 100 American Institute of Architecture Awards, and numerous other design recognitions. Morphosis works have been published extensively. The firm has been the subject of numerous exhibitions and 25 monographs.

## MccGwire, Kate

Kate MccGwire is an internationally renowned British sculptor whose practice probes the beauty inherent in duality, employing natural materials to explore the play of opposites at an aesthetic, intellectual, and visceral level. Growing up on the Norfolk Broads, her connection with nature and fascination with birds was nurtured from an early age, with avian subjects and materials a recurring theme in her artwork. Since graduating from the Royal College of Art in 2004 her uncanny sculptures have been exhibited at the Saatchi Gallery, the Museum of Art and Design (New York), and most recently at the Natural

History Museum (Paris). Kate is represented by All Visual Arts Gallery, London.

## Motter, Dean

Dean Motter, artist/writer/designer, relaunched his seminal comic book creation, the retro-futuristic *Mister X* in 2009 with the newly restored *Mister X: The Archives*, *The Brides of Mister X*, and followed by *Mister X: Condemned*. In recent years he has handled characters such as Wolverine for Marvel Comics, Superman and the Spirit for DC Comics, and produced the award-winning film-noir graphic novel *Batman: Nine Lives*. His acclaimed Vertigo miniseries, *Terminal City*, has recently been reprinted in *The Compleat Terminal City* by Dark Horse. Motter has also designed a number of award-winning album covers and book jackets. He is currently illustrating *The Book Hitler Didn't Want You to Read* for the Los Angeles Museum of the Holocaust and the authorized prequel to the classic Fritz Lang film *Metropolis*.

## Nabian, Nashid

Nashid Nabian was born and raised in Tehran, Iran, and earned a masters in architectural engineering at Shahid Beheshti University. She pursued her post-graduate studies at the University of Toronto's Daniels Faculty of Architecture, Landscape and Design, where she earned a master of urban design degree, and received the Toronto Association of Young Architects award for her thesis on the enhancement of the Toronto Waterfront. From 2003 to 2012, she was partner at Arsh Design Studio, a Tehran-based architecture office both nationally and internationally recognized for its projects: Dollat II, a residential apartment by Arsh Design Studio, has been shortlisted for the 2010 cycle of the Agha Khan Architecture award, while 2 Offices/2 Brothers, an office building by Arsh Design Studio, was shortlisted for 2011 WAF award. In 2012, after Arsh Design Studio was divided into two separate offices, she co- founded [Shift] Process Practice with Rambod Eilkhani. She holds a doctor of design degree from the Harvard Graduate School of Design and she has been involved in various projects at MIT SENSEable City Lab as part of her two year post-doctoral fellowship at the lab. As a faculty member at the Harvard Graduate School of Design she collaborates on various research-driven projects at GSD REA Lab.

## Nam, Daisy

Daisy Nam is the assistant director of public programs at Columbia University School of the Arts, where she works with artists and thinkers to engage with the campus community and public at large. Previously, she worked at the Guggenheim Museum on initiatives that support the museum's collection, exhibition and educational programming. She is also currently pursuing further studies in art history and critical theory.

## Navarro Alemany, Javier

Javier Navarro Alemany is an architect currently moonlighting as a waiter in Barcelona, Spain.

## Nishimoto, Taeg

Taeg Nishimoto was born in Osaka, Japan. He is a graduate of Waseda University in Tokyo, and Graduate School of Architecture at Cornell University. He worked in Architektenburo Herman Hertzberger in Amsterdam and Kunihiko Hayakawa and Associates in Tokyo. From 1985 to 2001, he maintained his practice, Taeg Nishimoto + Allied Architects in New York City, while teaching design studios at Columbia University and Pratt Institute. He is licensed in the state of New York and Japan. His built, unbuilt, and installation work has been widely published, including *GA HOUSES*, *l'ARCA*, and *Shinkenchiku*. His "PLOT Houses" project is in the permanent collection of FRAC Centre in France. In 2001, he joined Texas A&M University, and since 2007, he has been at the University of Texas at San Antonio as full professor and is now also associate dean for research, outreach, and graduate studies of College of Architecture.

## Norton, Tom

Tom Norton is an artist, designer and inventor. Born in New York City in 1941, Tom received his bachelor of fine arts from the Rhode Island School of Design. Tom Norton Designs is the manufacturer of Walnut Drawing Ink® and the Walnut Drawing Stick®. Tom lives in Cambridge, Massachusetts.

## Papapetros, Spyros

Spyros Papapetros is associate professor of architectural theory and historiography, Behrman faculty fellow, and member of the program in media and modernity at Princeton University. He studies the intersections between art, archi-

tecture, historiography, psychoanalysis, and the history of psychological aesthetics. He is the recipient of fellowships by the Getty Research Institute, the Institute for Advanced Study, the Canadian Center for Architecture, the Barr Ferree Foundation, the Townsend Center for the Humanities, and the Fulbright Program. He is the author of *On the Animation of the Inorganic: Art, Architecture, and the Extension of Life* (Chicago: Chicago University Press, 2012) and the editor of *Space as Membrane* by Siegfried Ebeling (London: Architectural Association, 2010). His essays and reviews have appeared in the journals *RES*, *Grey Room*, the *Getty Research Journal*, *JAE*, *Oxford Art Journal*, *AA Files*, *JSAH*, and in numerous edited anthologies.

## Payne, Jason

Jason Payne is an assistant professor of architecture at University of California Los Angeles and principal of Hirsuta LLC. He holds a bachelor of architecture degree from Southern California Institute of Architecture and a master of science, advanced architectural design degree from Columbia University. Prior to founding Hirsuta in 2008, he worked as project designer for Reiser + Umemoto/RUR Architects and Daniel Libeskind Studio and co-partnered the award-winning office Gnuform. He has held teaching positions at the Ohio State University, Rice University, Pratt Institute, Rensselaer Polytechnic Institute, and Bennington College. Committed to the creative synthesis of scholarship and practice, Payne has established a reputation as a leading designer and educator in his generation. Hirsuta LLC is a boutique architectural practice located in Los Angeles, California. Hirsuta pursues both built and speculative projects with a commitment to the integration of research and practice.

## Rothstein, Karla

Karla Maria Rothstein is an architect and an educator, practicing in these intertwined disciplines for nearly twenty years. Since 1997, Rothstein has taught design studios in the Graduate School of Architecture at Columbia University, where she is associate professor. Her areas of research span the intimate spaces of urban domestic life, death, and memory, to intersections of social justice and the built environment. Rothstein was a Jacob Javits Fellow in Fine Arts from 1988 to 1992, a William Kinne Traveling Fellow in the Extreme North of Cameroon in 1992, and a NYFA recipient in 2000. Through Latent Productions, where Rothstein is design director, she and Salvatore Perry lead a talented team to employ the catalysts of real estate development and research to reconstitute the nature and prospects of architectural practice. Operating at the nexus of architecture, finance, and inquiry, Latent liberates the specific potential embedded within every project while celebrating spatial experience and material quality. Rothstein's work has been published internationally, including in the *New York Times*, *Architecture Magazine*, *Casabella*, *Detail*, and most recently in Kenneth Frampton's second edition of *American Masterworks* (Rizzoli 2010). She is currently developing a chapter for *New Realities* and *Controversies of Dying in America* (Praeger 2013).

## Rowe, Heather

Heather Rowe is an artist based in Brooklyn, New York, who received her MFA from Columbia University. She has exhibited in numerous museums and galleries including PS1/MoMA, Long Island City, New York; the Indianapolis Museum of Art, Indianapolis, Indiana; UMMA/University of Michigan Museum of Art, Ann Arbor, Michigan; Galerie Zink, Berlin, Germany; D'amelio Terras, New York; Michael Benevento Gallery, Los Angeles; Ballroom Marfa, Texas; Andrea Rosen, New York; White Columns, New York; and Artists Space, New York; and in 2008, her work was featured in the Whitney Biennial.

## Rueb, Teri

Teri Rueb works at the intersection of mobile media, sound, land, and environmental art. She has received numerous awards including a Prix Ars Electronica Award (2008) and nominations for a CalArts Alpert Award (2012), the Rockefeller New Media Award (2006, 2007), and the Boston ICA Foster Prize (2007, 2008). She has recently been artist resident at the Santa Fe Art Institute, the Banff Centre for the Arts, and the Harvard metaLab. Her work has been funded by the Banff Center for the Arts, Edith Russ Haus für Medienkunst, La Panacée, Boston ICA/Vita Brevis Temporary Outdoor Art Program, LEF, Turbulence.org, Artslink, and the Arnold Arboretum, Harvard University. She

lectures internationally and publishes her writings, most notably with MIT Press, Routledge, and the University of Minnesota Press. Rueb is professor in the Media Study Department at the University at Buffalo, where she is founder/director of the Open Air Institute.

## Safran, Yehuda E.

Yehuda Emmanuel Safran studied art at St. Martin School of Art, architecture at the Royal College of Art and philosophy at University College London. Earlier, he designed theater sets for Ibsen's *Goust*, Maxwell's *Winterset*, Chekov's *Swan Song*, *inter alia*. He teaches at Columbia University Graduate School of Architecture, Planning and Preservation and Pratt Institute. He has published on cinema, art, and architecture in several languages and continents. His work as a sculptor was exhibited in the Serpentine Gallery London (1975). He is the director of Potlatch, Research in Art and Architecture Lab and Journal. He is currently working on an exhibition and publication: *Adolf Loos: Our Contemporary* to be opened in December in CAAA Guimareas, Portugal, in March at the MAK Vienna, and later at Columbia University Graduate School of Architecture, Planning and Preservation. His book on Adolf Loos will be published in Paris by Hachette. He lives and works in New York where he is a consultant to Steven Holl, Architects.

## Sams, Pamela

Pamela Sams AIA LEED AP is a senior project architect and a sustainable manager at the Washington, D.C., office of HOK, a global design firm. In the twelve years that she has worked at HOK, she has been a part of design teams designing and building many innovative, large-scale, and complex projects in the U.S., Africa, Europe, and the Middle East. She was a project leader on the Western Expansion of Concourse B for Dulles Airport; Oqyana-World First, a multiuse development on built islands off of the coast of Dubai; and most recently she completed work on a new Forensic Laboratory Campus for the Department of Justice. Before working at HOK, she worked and taught in Paris and Ireland. She received her master of architecture from Princeton University and her BFA from Parsons School of Design. She lives near D.C. with her husband and son. Her grown daughter lives in New York City.

## Schafer, Ashley

A writer, editor, designer, and licensed architect, Ashley Schafer has lectured and published her design work and critical essays internationally. She is co-founder and co-editor of the journal Praxis. Under her direction, the journal has received critical acclaim as well as numerous grants, awards, and honors, including two from the National Endowment for the Arts and an ID design award. Schafer is an associate professor at the Ohio State University Knowlton School of Architecture, where she previously served as the head of the architecture department. She has held appointments as an associate professor at Harvard University Graduate School of Design and Tulane University as well as a visiting professorship at the Massachusetts Institute of Technology. Schafer holds a BS in architecture from the University of Virginia and her master of architecture from Columbia University Graduate School of Architecture, Planning and Preservation.

## Schwartz, Richard Evan

Richard Evan Schwartz is the Chancellor's professor of mathematics at Brown University. Schwartz has received fellowships from the Alfred P. Sloan Foundation, the John Simon Guggenheim Foundation, the Clay Foundation, the Simons Foundation, and the Leverhulme Trust. He has been a visiting member of the Institut des Hautes Etudes Scientifiques, the Institute for Advanced Study in Princeton, and the Max Planck Institute in Bonn, Germany. He is currently a visiting fellow at All Souls College, Oxford. His research involves the theoretical and experimental exploration of poorly understood phenomena in geometry and dynamical systems. He often explores simply-stated but deceptively deep problems with graphical user interfaces which he programs himself. He has published numerous research articles as well as two research monographs, one textbook, and one children's book about numbers. He writes and illustrates comic books in his spare time.

## Sha Xin Wei

Sha Xin Wei, PhD, is Canada research chair in media arts and sciences, and associate professor of fine arts at Concordia University in Montréal, Canada. He directs the Topological Media Lab, an atelier-laboratory for the study of gesture and

materiality from computational and phenomenological perspectives. Sha studies process and morphogenesis by creating responsive environments for ethico-aesthetic improvisation. Sha's art research includes the TGarden responsive environments, Hubbub speech-sensitive urban surfaces the WYSIWYG gesture-sensitive sounding weaving, Ouija performance-installations, and the IL Y A video membrane. Sha is an editor of the journal *AI and Society*; the Rodopi Press book series *Experimental Practices in Art, Science, and Philosophy*; *FibreCulture*; and the *International Journal of Creative Interfaces and Computer Graphics*. His publications include articles in *Configurations*, *Modern Drama*, *AI and Society*, *Revue Française d'Etudes Américaines*, and *Theory, Culture, and Society*, International Computer Music Association, ACM Multimedia, Ubicomp, International Symposium on Wearable Computers. Sha's current book, *Poiesis and Enchantment in Topological Matter*, is in production with MIT Press.

## Solomonoff, Galia

Galia Solomonoff is the founder and creative director of Solomonoff Architecture Studio. She received her master's in architecture from Columbia University, where she was awarded the McKim Prize for Excellence in Design and the William Kinne Fellows Traveling Prize. She received her BA from City College, where she was named best student of the School of Architecture in 1990. Prior to founding SAS, Solomonoff worked with OMA/Rem Koolhaas, Rafael Vinoly, and Bernard Tschumi Architects, as well as OpenOffice, which she co-founded. She has taught at the Rhode Island School of Design, Princeton University, Cooper Union, Yale University, and Columbia University's Graduate School of Architecture, Planning and Preservation. Solomonoff is the recipient of two AIA Design Awards, grants from the New York Foundation for the Arts, and the National Endowment for the Arts, and recognition in the Architectural League of New York's Emerging Voices series. *New York Magazine* called Dia: Beacon, which Solomonoff designed with OpenOffice, "one of today's most compelling new buildings," and named Solomonoff part of the next wave of designers. Her work—which ranges in scale from apartments to townhouses to large museum projects—has appeared in the *New York Times*,

*The New Yorker*, *W*, *ARTNews*, *Artforum*, and *Domus*. Solomonoff's projects have been included in the books *Trespassing: Houses x Artists*, *Allison Arieff's Prefab*, and the *Vitra Design Museum's Living in Motion*, and her writing on topics related to contemporary art, culture, architecture, and urbanism has appeared in *Layered Urbanisms*, *Perspecta*, *Latin American Architecture: Six Voices*, and *Post Ductility: Metals in Architecture and Engineering*. Solomonoff grew up in Rosario, Argentina, and now lives in Manhattan.

## Tehrani, Nader

Nader Tehrani is a principal and founder of NADAAA, a practice dedicated to design innovation, fabrication, interdisciplinary collaboration, and productive dialogue with the construction industry. Tehrani is also a professor and head of the department of architecture at MIT. As a founding principal of Office dA, Tehrani received the Cooper-Hewitt National Design Award in Architecture, the American Academy of Arts and Letters Award in Architecture, the United States Artists Architecture and Design Award, and thirteen Progressive Architecture Awards. He was principal-in-charge of various projects including the Tongxian Art Gatehouse, the Fleet Library, Banq restaurant, Helios House, the LEED-Gold certified Macallen Building, and Hinman Research Building. Tehrani received a BFA and a bachelor of architecture from the Rhode Island School of Design in 1985 and 1986, and received his MAUD from Harvard Graduate School of Design in 1991. Tehrani has taught at Northeastern University, Rhode Island School of Design, and Harvard Graduate School of Design.

## Tsurumaki, Marc

Marc Tsurumaki is principal and founding partner of Lewis.Tsurumaki.Lewis (LTL Architects), an innovative, award-winning architecture partnership founded in 1997 with Paul Lewis and David J. Lewis and located in New York City. LTL's work has been published extensively and exhibited internationally. LTL Architects is the recipient of the 2007 National Design Award for Interior Design from Cooper-Hewitt and was featured in the U.S. Pavilion at the 2004 Venice Architecture Biennale and the inaugural National Design Triennial at Cooper-Hewitt

in 2000. Their work is in the permanent collections of the San Francisco MoMA and the Heinz Architectural Center. The principals are co-authors of the monograph *Opportunistic Architecture and Situation Normal ... Pamphlet Architecture* #21. Their second monograph, *Intensities* (Princeton Architectural Press), was released in the fall of 2012. Marc Tsurumaki is a licensed architect and received a BS in Architecture from the University of Virginia and a master of architecture from Princeton University. Tsurumaki is an adjunct assistant professor of architecture at Columbia University Graduate School of Architecture, Planning and Preservation, and has taught at a number of institutions including MIT, Parsons School of Design, Syracuse University, and Yale University as the 2006 Louis I. Kahn visiting professor.

## Varnelis, Kazys

Kazys Varnelis is director of the Network Architecture Lab at the Columbia University Graduate School of Architecture, Planning and Preservation, where he is also on the architecture faculty, teaching studios and seminars in history, theory, and research. Varnelis is a co-founder of the conceptual architecture/media group AUDC, which published *Blue Monday: Absurd Realities and Natural Histories* in 2007 and has exhibited widely in places such as High Desert Test Sites. He edited the *Infrastructural City, Networked Ecologies in Los Angeles, Networked Publics*, and *The Philip Johnson Tapes*, all published in 2008. He has worked with the Center for Land Use Interpretation and produced the *New City Reader: A Newspaper of Public Space* with Joseph Grima as part of the *Last Newspaper* exhibition at the New Museum in the fall of 2010. Varnelis' teaching and research focuses on the impact of changes in telecommunications, economics, and demographics on architecture, the city, art, and culture. He is presently writing a book titled *Life After Networks: A Critical History of Network Culture*.

## Veikos, Catherine

Catherine Veikos is an associate professor of architecture at the California College of the Arts in San Francisco (CCA), an architect, and a writer. Her scholarship engages contemporary issues related to the design of surfaces, image theory, and representation. Her work has been published in *AD*, the *Journal of Architectural Education, Metropolis, SPACE*, and *ARQTexto*. Her book, *Lina Bo Bardi: The Theory of Architecture Practice* (2013), introduces a translation of the architect's 1957 thesis. Veikos studied architecture and English at Barnard College and holds a master of architecture from the Harvard Graduate School of Design. She was the Cass Gilbert professor at the University of Minnesota and has taught at Tulane, the Illinois Institute of Technology, the University of Pennsylvania, and the University of California, Berkeley. She is currently the chair of the Interior Design Program at CCA.

## Vidler, Anthony

Anthony Vidler received his professional degree in architecture from Cambridge University in England, and his doctorate in history and theory from the University of Technology, Delft, the Netherlands. Vidler was a member of the Princeton University School of Architecture faculty 1965-93, serving as the William R. Kenan Jr. chair of architecture, and was appointed dean of the Irwin S. Chanin School of Architecture of Cooper Union in 2002. A historian and critic of modern and contemporary architecture, specializing in French architecture from the Enlightenment to the present, Vidler has received awards from the Guggenheim Foundation, the National Endowment for the Humanities; he was a Getty Scholar, at the Getty Center for the History of Art and the Humanities 1992-93 and a Senior Mellon Fellow at the Canadian Centre of Architecture, Montreal, in 2005. His publications include *The Writing of the Walls: Architectural Theory in the Late Enlightenment* (Princeton Architectural Press, 1987); *Claude-Nicolas Ledoux: Architecture and Social Reform at the End of the Ancien Regime* (MIT Press, 1990), which received the Henry-Russell Hitchcock Award from the Society of Architectural Historians; *The Architectural Uncanny: Essays in the Modern Unhomely* (MIT Press, 1992); *Warped Space: Architecture and Anxiety in Modern Culture* (MIT Press, 2000); *Histories of the Immediate Present: The Invention of Architectural Modernism* (MIT Press, 2008); *James Frazer Stirling: Notes from the Archive* (Yale University Press, 2010); and *The Scenes of the Street and Other Essays* (Monacelli Press, 2011). He is a fellow of the American Academy of Arts and Sciences and

received the architecture award from the American Academy of Arts and Letters in 2011.

## Walker, Enrique

Enrique Walker is an architect. He is associate professor at the Graduate School of Architecture, Planning and Preservation, Columbia University, where he also directs the master of science program in Advanced Architectural Design. In addition, he has taught at the Escuela Técnica Superior de Arquitectura de Madrid (ETSAM), the Barcelona Institute of Architecture (BI-Arch), the Tokyo Institute of Technology, the Pratt Institute, and the Universidad de Chile. His publications include the books *Tschumi on Architecture: Conversations with Enrique Walker* (New York: The Monacelli Press, 2006) and *Lo Ordinario* (Barcelona: Editorial Gustavo Gili, 2010), as well as the articles "Scaffoldings," in *From Rules to Constraints: Luis M. Mansilla + Emilio Tuñón*, edited by Giancarlo Valle (Zurich: Lars Müller, 2012); "Under Constraint," in *Architecture as a Craft*, edited by Michiel Riedijk (Amsterdam: SUN, 2011); "Compendium," in *The Architectures of Atelier Bow-Wow: Behaviorology* (New York: Rizzoli, 2010); "Fireworks," in *First Works: Emerging Architectural Experimentation* of the 1960s and 1970s, edited by Brett Steele and Francisco González de Canales (London: Architectural Association, 2009); "Erratum," in *Office Kersten Geers David Van Severen: Seven Rooms* (Antwerp: deSingel International Art Campus, 2009); "Bajo Constricción (Prefacio)," in *Circo 140* (2007); and "Bajo Constricción (Postfacio)," in *Circo 141* (2007).

## Wei Jia

Wei Jia, born in 1957 in Beijing, China, is an independent artist living in New York and Beijing. He studied Chinese traditional painting, poetry, and calligraphy from a very early age, and received a BFA in oil painting from the Central Academy of Fine Arts, Beijing and an MA in studio art from Bloomsburg University in Pennsylvania. Wei Jia collages Chinese Xuan paper and translucent surfaces—in a process of mounting, painting, tearing, and mounting paper over and over again on canvas—to create forms, texture, layers, and marks. Full of unexpected accidents, chances, and opportunities, his works allow for visual travels on canvas by the viewer.

## Wigley, Mark

An accomplished scholar and design teacher, Mark Wigley has written extensively on the theory and practice of architecture and is the author of *Constant's New Babylon: The Hyper-Architecture of Desire* (1998); *White Walls, Designer Dresses: The Fashioning of Modern Architecture* (1995); and *The Architecture of Deconstruction: Derrida's Haunt* (1993). He co-edited *The Activist Drawing: Retracing Situationalist Architectures from Constant's New Babylon to Beyond* (2001). Wigley has served as curator for widely attended exhibitions at the Museum of Modern Art, New York; the Drawing Center, New York; Canadian Centre for Architecture, Montreal; and Witte de With Museum, Rotterdam. He received both his bachelor of architecture (1979) and his PhD (1987) from the University of Auckland, New Zealand.

## Wilson, Mabel O.

Mabel O. Wilson navigates her transdisciplinary practice Studio AND between the fields of architecture, art, and cultural history. In 2011 she was honored as a United States Artists Ford Fellow in architecture and design. Her scholarly essays have appeared in numerous journals and books on critical geography, memory studies, art, and architecture. She is the author of *Negro Building: Black Americans in the World of Fairs and Museums* (University of California Press, 2012). As the Nancy and George E. Rupp professor, she teaches architectural design and theory courses at Columbia University's Graduate School Architecture, Planning and Preservation, where she also directs the graduate program in advanced architectural research. She is also appointed as a senior fellow at the Institute for Research in African-American Studies.

## Xu Bing

Xu Bing was born in 1955 in Chongqing, China, but grew up in Beijing. During the final years of the Cultural Revolution he was sent to the countryside to perform farm labor as an "educated youth." He entered the Central Academy of Fine Arts (CAFA) in 1977, where he studied and taught in the printmaking department, receiving both his bachelor's and master's degrees there. In 1990 Xu moved to the United States, eventually relocating to New York in 1992. His work has been the subject of numerous solo

and group exhibitions at museums spanning the globe and has been included in various art history textbooks. In 1999 Xu Bing received a MacArthur Fellowship and was awarded an honorary doctorate from Columbia University in 2010. He currently works out of his studios in Beijing and Brooklyn, New York, and since January 2008 has served as vice president of CAFA, his alma mater.

### Xu Li

Erik Xu Li is a member of the China Cultural Academy, and the former chief editor of *ABITARECHINA*. He is currently engaged in the study of Chinese classical landscape gardens and ancient Chinese painting and calligraphy. His recent work includes the design and construction of a Qing Dynasty garden in Soochow, and the identification of ancient Chinese (Song and Yuan Dynasties) calligraphy seals.

### Yang, Soo-In

Soo-in Yang leads a design studio called Lifethings based in Seoul, Korea. His work intersects the scales of cities, buildings, public artworks, and palm-sized interfaces. In 2011, he introduced *Show of Thumbs*, an artwork that designs a lobby wall based on collective input from people's text message votes, at Gwangju Design Biennale. Yang recently completed a 200-square-meter net zero energy house in Namhae, Korea. Yang earned his bachelor of architectural engineering from Yonsei University, Korea, and master of architecture from Columbia University.

### Young, Michael

Michael Young is an architect and educator practicing in New York City, where he is a founding partner of the architectural design practice Young & Ayata. Their design work and research has been exhibited nationally and internationally. Michael currently teaches studios and seminars at Cooper Union, Yale University, Columbia University, and Princeton University. His drawings have been exhibited recently in New York, Los Angeles, and Lexington, Kentucky and are featured as part of the Drawing Center's viewing program. In addition to teaching and practicing, Michael is invested in writing, research, and experimentation on issues concerning aesthetics and architectural mediation.